Elliott Erwitt: On The Beach

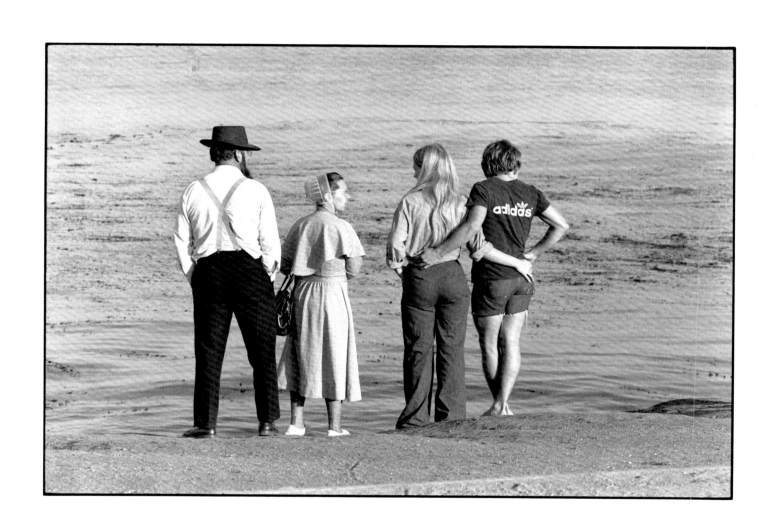

Elliott Erwitt: On The Beach

W.W. Norton & Company

New York London

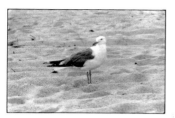 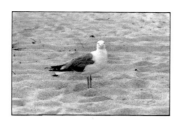 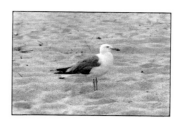 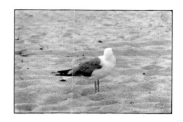

First Edition

page 2:
Santa Cruz, California,1975

above:
East Hampton, New York, 1990

Designed by Katy Homans
Typeset in Helvetica by Trufont Typographers
Printed and bound by Imprimerie Jean Genoud, SA Switzerland

None of the photographs in this book have been
electronically altered or manipulated

ISBN 0-393-03028-8

W.W. Norton & Company, Inc., 500 Fifth Avenue, New York, N.Y. 10110
W.W. Norton & Company, Ltd., 10 Coptic Street, London WC1A 1PU

1 2 3 4 5 6 7 8 9 0

Printed in Switzerland

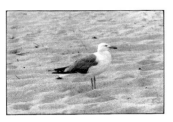 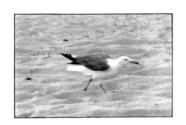 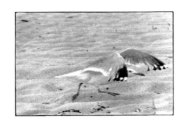 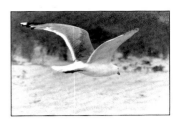

For my children and their children . . .
and my steadfast colleague Douglas Rice.

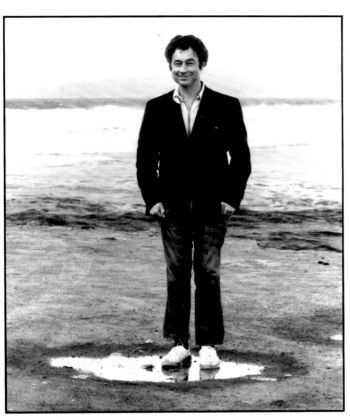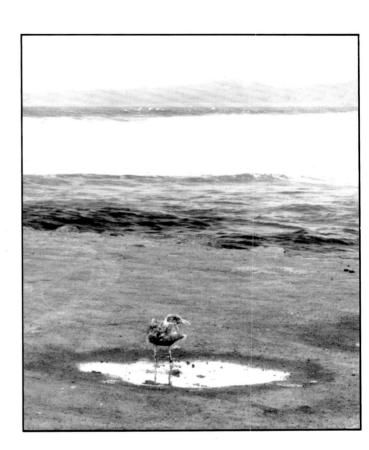

Elliott Erwitt, California, 1977 (left pix by João Passerby)

I've been taking pictures on beaches ever since I've been taking pictures, because it reflects my general attitude toward life: Combine work with pleasure. You look at girls; you get a suntan; you might catch a photo that works.

When I was growing up in Italy, each summer we spent one month at the beach and one month in the mountains, like all good middle-class Italian families in those days. It was like a Jacques Tati film. You went to the beach to learn how to swim, then came home to your villa for a nice lunch and siesta. Fifty years ago I was just a little kid, not looking for girls or even at girls, but somehow those early memories, half-conscious or unconscious, have something to do with the situations my camera has been attracted to.

I was surprised myself to find that I have taken beach pictures virtually throughout my entire career. There are snaps from Mexico, Uruguay, Brazil, Italy, Russia, California, Normandy, Long Island. I took beach pictures with my first camera when I was sixteen in Southern California. If I'm still alive, I will have taken some since this book went to press.

I hope these photos show that I believe that no one is beyond ridicule. No one. That's fundamental. But there is a thin line between being humorous and being nasty, and I never mean to ridicule anyone in a bad way. Gently, or even sharply maybe, but never with malice. It is very important not to be mean in pictures. And you'd be surprised . . . some photographers, some of the nicest people you ever want to meet socially, will take the cruelest pictures. It's like their signature: wonderful, but with something hard, abrasive, unpleasant coming out.

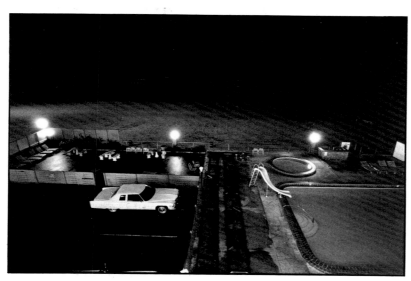

Florida, 1975

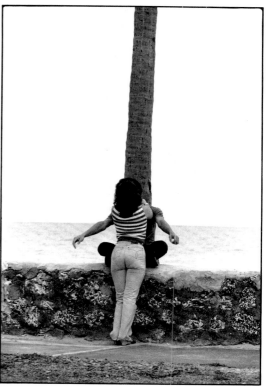

Key West, Florida, 1980

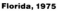

If people have to build a swimming pool next to the beach, you'd think that at least they would have the sensitivity to hide it somehow. It makes fun of the beach. It's really quite arrogant and insulting.

People who hate puns get angry at my photos. I don't know why they get so upset, and I don't think I'm really a visual punster—well, maybe on Fridays—but that's the criticism.

I get in a lousy mood if I make the mistake of going to the beach without a camera and then see a picture happen. When I do take a camera, I have to remember to moderate myself. Girlfriends or my kids can get pissy, because I'm not really at the beach with them. I'm there alone with my camera.

Some of the people I've photographed in formal situations might look interesting on the beach. I'd love to see Nixon or de Gaulle there. Actually I did see Nixon once. Right after the '68 election his people invited an army of photographers down to Bebe Rebozo's hideout in Key Biscayne. Nixon had always been jealous of the JFK image: outdoorsy, athletic, walking on the beach with his young son. So we were given the opportunity of recording the leader of the free world as a simple man walking alone on the beach, communing with the sea. The Secret Service agents stood back, we arranged our phalanx, and this solitary figure appeared, pretending he was John Kennedy. Except he was wearing a blue suit, a white shirt with tie, black dress shoes. Wonderful.

You can't beat seeing the beach from your room in a cheap motel. I'm a motel freak. I like the kind with broken screen doors and linoleum floors that heave a little. You get the strong smell of the sea, and you pick up half a flask of bourbon and feel a little bit sorry for yourself. It's a lot better than sitting and staring into a fire.

None of these snaps was taken with a tripod. Since beach photography requires stealth, you can't use one. You don't have to worry about too much light, as some people do. A picture is taken with the same amount of light hitting the film whether there is a lot of light or very little. You just compensate. What makes the difference is the way you regulate it. I keep technical things to a minimum, by the way. They bore me. I am used to my camera and work without thinking about its personal problems. I think about pictures, not mechanics.

Have a decoy, preferably of the opposite sex; pretend to shoot your decoy's picture; shoot between her ear and her shoulder with a 200 mm lens while directly facing anyone who might discover you. A long lens seen down the barrel does not appear long and will not give alarm.

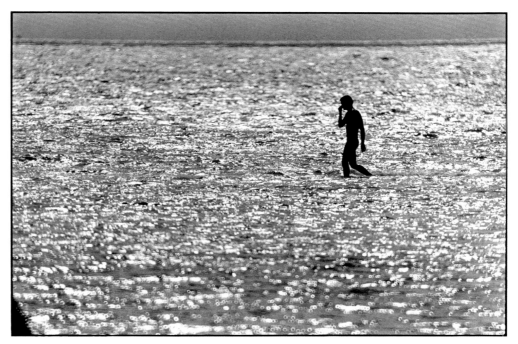

Key West, Florida, 1982

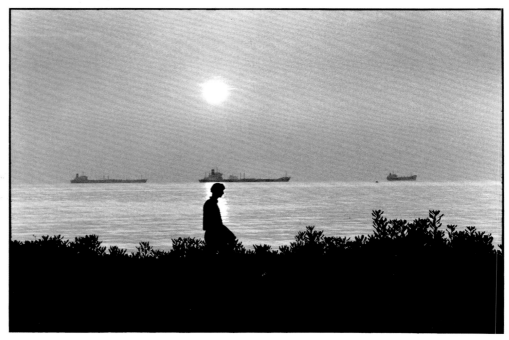

Trieste, Italy,1990

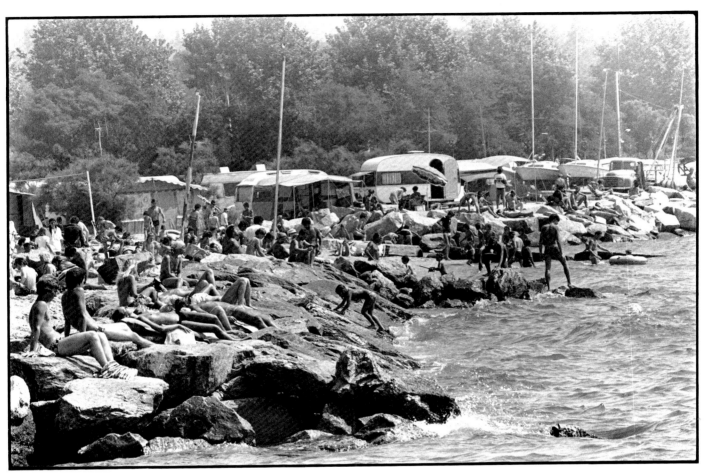

Ste. Maxime, France 1978

Everyone complains about how crowded urban life has become. They go to the beach, to those wonderful wide open spaces . . . and pile on top of each other.

Some of these photos show people packed together like the rush-hour subway, and some show isolation. Now, isolation doesn't mean loneliness. Some people see a wistfulness in some of these shots, and I can agree with that. A slight gloominess, maybe, but only slight . . .

People sometimes see "melancholy" in some of these photos. That word's too clunky for me. When I grew up in Italy, there was a better way of saying it: *"Ho la luna in mezzo mare."* Something like "I feel as if I'm watching the moon sink in mid-sea." Yes, that's melancholy, but there is a whole picture in those words. The words conjure up the picture, but they are only words.

People at the beach act pretty much the way they do in their daily lives, but the contrasts are clearer. They segregate themselves. Near my house in Amagansett in the late 1960s, the age of the singles, there was a spot called Asparagus Beach because the girls and boys were packed so tightly, looking for each other. They ignored the other hundred or so miles of Long Island beach. With AIDS, that's changed, so that stretch has become a family beach. Then there's a homosexual beach and a lesbian beach, evenly divided by a road—tight little neighborhoods, just like back in the city.

There is one "great figure" here. The little old man in a suit walking into the surf under an umbrella (held by his female companion) is Pablo Casals with his young wife, Martita (page 120). This is not a "found" picture. He was in his nineties and taking his regular morning constitutional, walking the beach in a dark suit even though it was 110 degrees in Puerto Rico. When we got back to his house, he asked very sweetly if I minded if he played for me. "Go right ahead," I said. He took out his cello and started some Bach. After a while he said, "I'm getting a little tired. Do you mind if I continue on the piano?" I did not. He rose and went over to the piano and continued to the end of the piece. We didn't know each other very well, but we became acquainted because he liked one of my pictures, which was a kind of beach photo. Sometime before, I had been hired to take a picture of him for the poster of a music festival, but he had had a heart attack. I borrowed a cello and stuck it in the sand beside a chair with the ocean in the background— a symbolic picture that evoked the Casals presence. When I visited, he had it stuck on the wall.

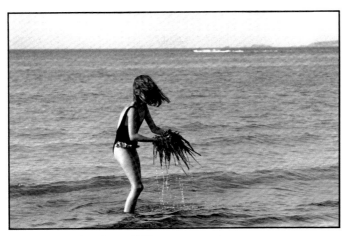

Amy Erwitt, Corsica, France 1990

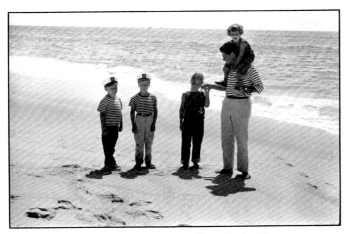

David, Misha, Ellen, Elliott with Jennifer Erwitt on his shoulders,
East Hampton, New York, 1963 (photo by João Passerby)

Sasha and Amy Erwitt, East Hampton, New York, 1984

Hardly anything comes between you and your children at the beach. No tele-
phone, no distractions, just you and your kids. They will remember these
days. The sea and clouds and surf are there, but they don't impinge. Nothing inter-
feres . . . except the occasional picture.

Children at the beach are almost as uninhibited as dogs, until at a certain age
they start looking at themselves. Little children, unself-conscious children, are
poignant to me, partly because I spend a lot of time at the beach with my
own children, thanks to my disorderly life—divorced father, taking his children

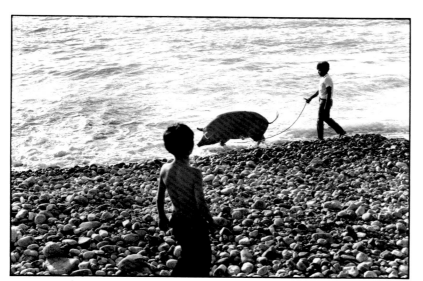

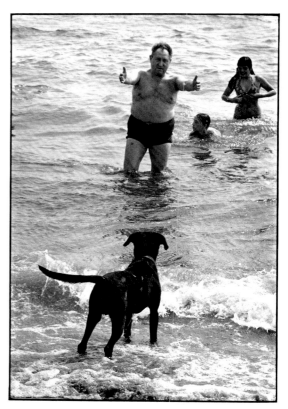

Puerto Vallarta, Mexico, 1973

Saintes Maries de la Mer, France, 1977

out on the weekend, then taking them back. You can't have mixed feelings about that. All my children have grown up more with their mothers than with me. I respond viscerally to children on the beach; I see that in some of these pictures, and other people do too.

Everyone says that the dogs in my pictures are people. I think that even the dogs who are not in my pictures are people. They're all especially happy when the human people pay more attention to them, as we do at the beach, throwing sticks or splashing around. Dogs belong at the beach, but you'd never see a cat at a beach. What would those nasty little creatures be doing there?

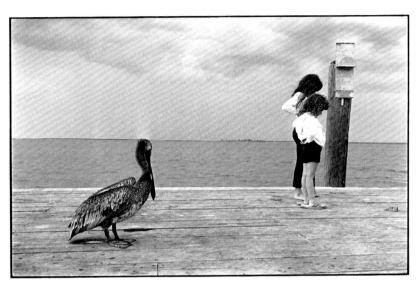

Sanibel Island, Florida, 1965

The dog pictures were taken at isolated beaches because most public beaches don't allow them. That's really too bad because dogs have a wonderful time at the beach. They don't know that they should try to be provocative and sexy. Let off the leash, they are just themselves.

For years I've been trying to take a really terrific picture of seagulls, but I've never succeeded. They're ever-present at the beach, of course, changing the landscape by moving about, making new configurations; but you never know where they're going to be or whether their wings are going to be half open or open all the way. You can use them in a large composition, but they're un-reliable. Generally, twenty feet (this is highly technical information) is about as close as you can get, no matter how slowly you advance. Any closer, they take off. Pelicans are more expressive, but they're rarer. If you had ostriches at the beach, you'd get much nicer close-ups.

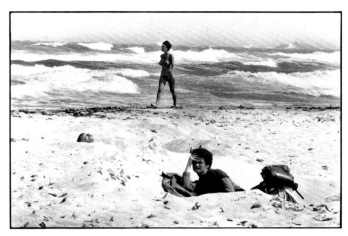
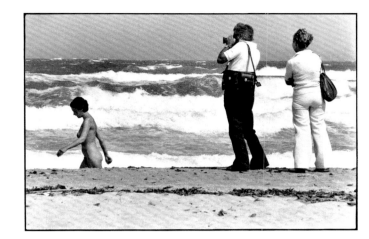

St. Tropez, France 1979

I realized I was a voyeur when I was sixteen. I haven't changed. No question about it, sexiness is an essential part of beachgoing. Voyeurism is the motivating force in many of these pictures, as it is in all of photography . . . for us photographers anyway.

The beach is license. Even in Anglo-Saxon countries, where bathing suits are comparatively modest, everyone knows that rules are suspended. You can ogle a man's seven-eighths naked wife—or worse, girlfriend—and he beams. Do that when they're walking down a city street some Saturday afternoon and you get clobbered.

If you're afraid of getting caught taking snaps, because you have expensive new dentures or something, I guess you should use an extreme telephoto lens, but I seldom do. It's not sporting.

If these were pictures in motion, you could see that people approach the water in different ways. That's why I take series of photos . . . sequences, not stories. In Brazil women always walk steadily toward the water. They never run. They get totally wet in only two waves and turn back. Always two . . . timed perfectly.

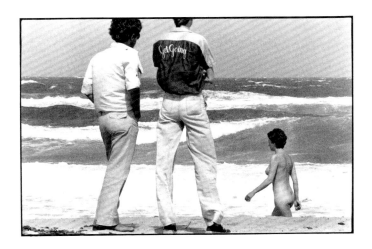 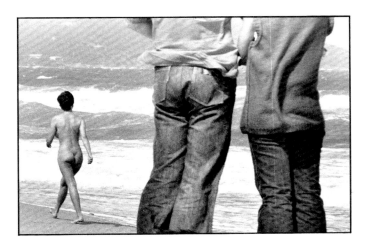

Americans get tans so they can show off. In South America they get better value: They show off while they're tanning. First phase: Get attention by sunning face-up. Second phase: Slowly roll over, shoulders first closely followed by the rest, to highlight the rear, as Latin men prefer.

Men like watching women at the beach, but they also like the social scene. Women have more complicated reasons for being there. Sure, they like the socializing, and they like the sensual pleasures of sun and water, but they always want to check out the competition—who's holding up, who's giving up.

The really expert beach types go mostly naked but keep little bits of stuff, strategically placed, to excite you. They're much sexier than people who simply take everything off.

In St. Tropez and places like that, the beautiful people want to be photographed, but they pretend they don't, and you have to go along with the game. It's a peculiar, unspoken contract . . . and both sides are delighted.

Unattractive people stay away from certain beaches, like Ipanema in Rio or St. Tropez, as a public service. But they don't stay away from Coney Island. French beaches, where you see artful exhibitionists, are different from American beaches, where people aren't quite so comfortable about being so close to naked in public. Nordic beaches are something else entirely. Swedes, say, think nothing of stripping down and displaying themselves, no matter what they look like. They don't care.

The beach is a better pickup spot than any cocktail party. There's always a lot of pawing going on. And you get the product properly displayed.

Nakedness can't hide what you are. At this very fancy nudist beach in Germany, on an expensive island that's hard to get to, you can see the nation's CEO's stark naked, potbellies sticking out, but acting as if they're socializing in a Hamburg salon. Once I saw two distinguished couples of a certain age approach each other, totally nude except for straw hats. They stopped, the men bowed and kissed the ladies' hands, the women nodded formally; then the couples went their separate ways. I can still get depressed at the thought that I missed that photo. I was too shy. And what was I shy about? They weren't.

In Rio the beach is a participant. At lunch hour, every day, thousands of office workers race down for a few minutes in the sun and water. In every way the city faces the beach. It even gets news from the beach. One year, when the military death squads were taking the homeless out beyond the surf and drowning them in groups, one man managed to escape. He made it, gasping, to the beach. His story became a theme of that year's Carnaval.

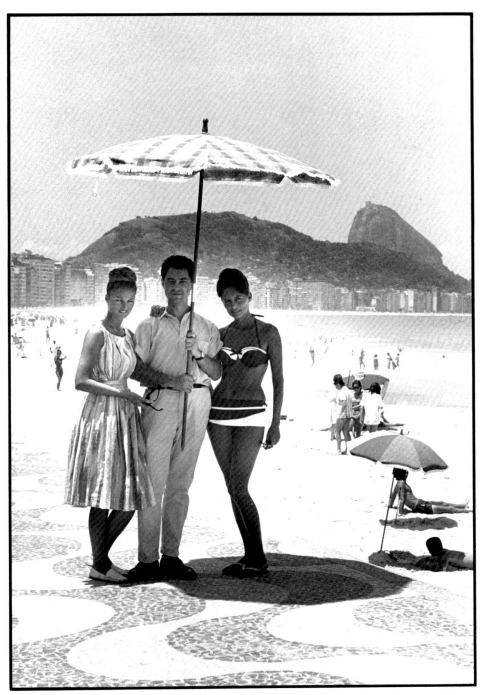

Rio de Janeiro, Brazil 1963 (photo by João Passerby)

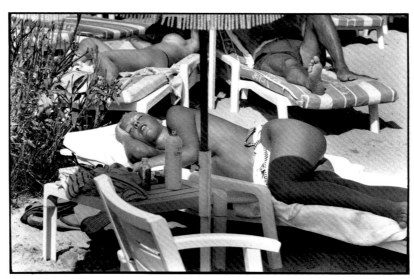

St.Tropez, France 1989

The preening at Capri is about the most extreme. Once I watched a gorgeous wo-
man emerge from the water and make her way up through the rocks. She was
quite unsteady, and it finally became clear that she was wearing high heels. She
didn't want to risk emerging from the water without her ammunition. She just
wanted to stand tall among her fellow men.

In Brazil the Beautiful People never get to the beach before 2:00 P.M. That's a
worldwide standard. BP women carry beach survival kits in small expensive
purses: compact mirror, big-toothed comb for wet hair, dark glasses, lipstick
colored like the day's bikini, hair barrettes, enough money for one drink. They
never actually wear the shades, and they never need more money: Other people
start buying.

Toplessness is quite standard at trendy European beaches these days. In South
America, where women cunningly appear more naked than anywhere else, all at-
tempts to go topless have provoked disaster: hissing, booing, and occasional
Bronx cheers. Nipples must never be seen *on the beach* . . . everything else, but
not the symbol of motherhood to a macho society.

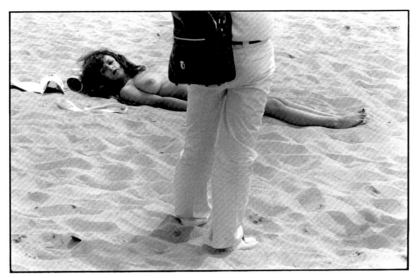

Cannes, France 1980

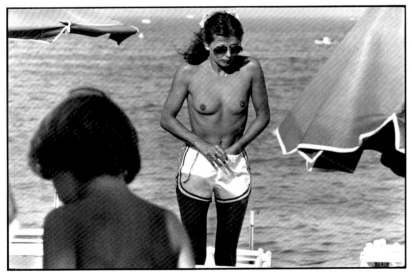

St. Tropez, France 1978

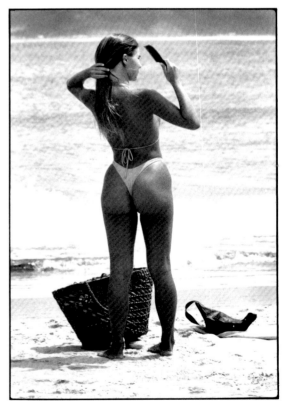

Buzios, Brazil 1990

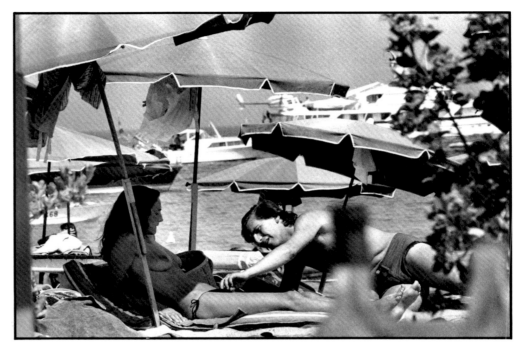

St. Tropez, France 1978

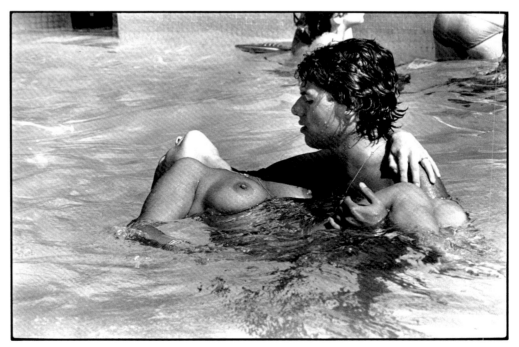

St. Tropez, France 1978

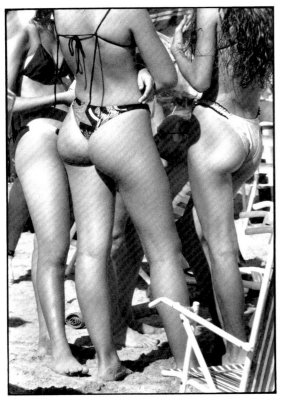

Rio de Janeiro, Brazil 1990

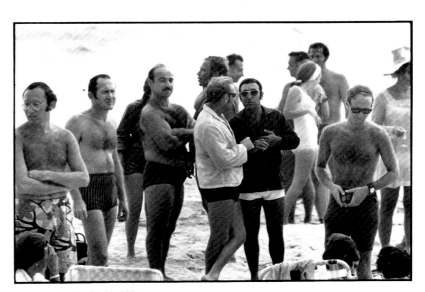

Amagansett, New York, 1969

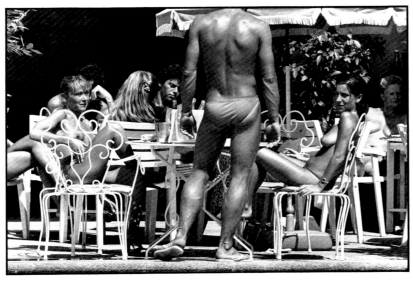

St. Tropez, France 1978

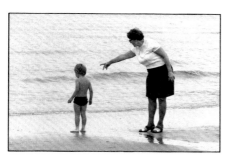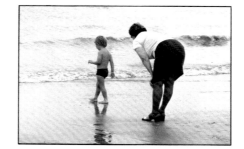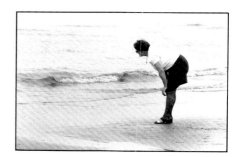

Blackpool, England 1975

The British go to the beach only to put it in its place. They fight it, putting on their best white shirts and ties. They stake out their territory and bring out their baked-bean sandwiches, or whatever they are, and then they sit. They engage in the sport of "paddling": you roll up the cuffs of your Sunday suit about three inches or so and place your feet in the water; then you stand immobile, communing with nature. (Or, if you're in Brighton, you stare warily toward France.)

The Irish are surrounded by the sea, but they have nothing to do with it. They don't even eat fish. I think they ship it all out. Maybe they're afraid of water. Maybe too much is going on in town or at the pub. Maybe everyone who liked the sea took off for good a long time ago. I've never seen the ones left behind pay any attention to it.

Beauty contests at the beaches of the British Isles are oddly touching. Groups of plain, pasty, working-class girls make themselves up and do their hair in the tartish way they see in movie magazines, a brassiness that might work in a studio but looks bizarre in bright sunlight. But everyone's happy. Their families, their boyfriends, the judges—everyone believes that this is glamour, and so it works. They'd be horrified by the models I work with. They'd be insulted by the international jet-set beauties in the south of France, with their little strings for suits. Well, who's to say . . .?

These three boys are the finalists in a kind of body-beautiful contest at the rigorously organized seaside camp for workmen and their families in the south of Wales. You can imagine the rest.

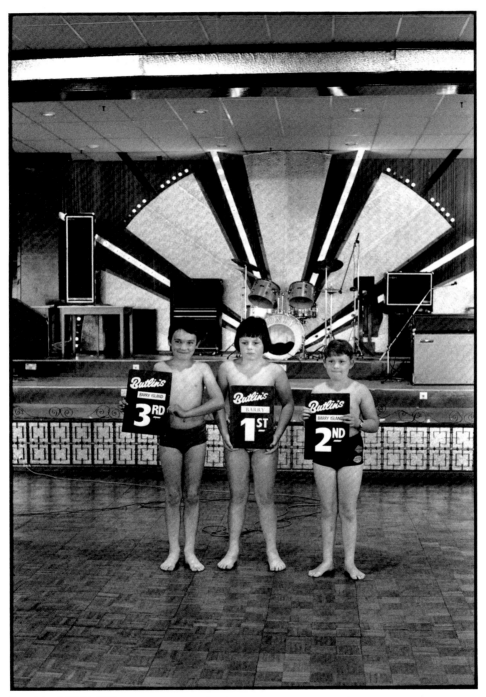

Barry Island, Wales, 1978

The dummies on the beach were contributed by the U.S. Army. I was drafted for the "Korean conflict" in 1951 and wound up doing my training with machine guns, bayonets, and live ammunition in what is fashionably known today as the Jersey shore. Back then, pre-condo development, the beach was a place where draftees couldn't do too much damage with live bullets. I usually carried a small camera in the pocket of my fatigues and took snaps during down time. Maybe this helped my aim. Testing had shown I could best distinguish myself as an anti-aircraft gunner. Alas, all those positions were filled.

Almost two decades after World War II, a soldier's skull and helmet were still lying on a deserted beach in the Solomon Islands. There's nothing romantic there. You fight off the mosquitos and pick your way through acres and acres of rusting metal—parts from airplanes that got shot down, slabs and skeletons of beached destroyers. You can't swim nearby because the sharks are waiting. The fish must have been told about the human sashimi that fell into the water back in the days of fire and noise.

I was in the Solomons to take pictures to illustrate Bob Donovan's magazine series about John Kennedy's wartime exploits. The articles gained a lot of attention as a book called *PT 109*. You see Bob and me with the islanders who actually helped rescue young Kennedy after his PT boat was rammed.

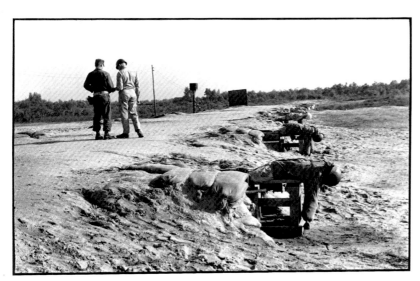

New Jersey, 1951

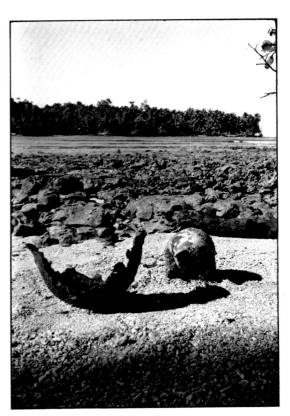

Solomon Islands 1961

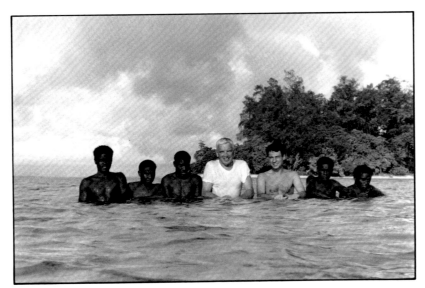

Munda, Solomon Islands 1961

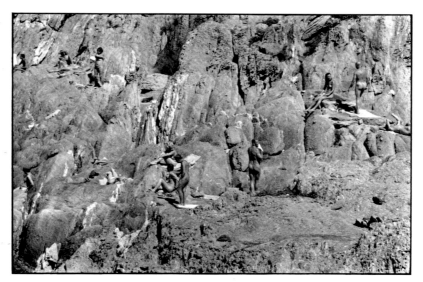

Ile du Levant, France 1968

Those naked people clambering around those hot, steaming cliffs are enjoying the unusually kinky appeal of the Île de Levant, a tiny, rocky island about twelve miles off the coast of southern France. Almost all of the tourists are nudists. They walk around the small town in the center of the island in so-called minimums—wee codpieces for men, with a minuscule zippered pouch for carrying a folded bill, and G-strings for women, cut even smaller because there's no money pouch. Quite casually they stroll the streets every afternoon among groups of young soldiers from the military base in uniform, who are lounging around on break from duty. It's the soldiers, of course, who look embarrassed, as if they're the ones who aren't properly dressed.

Slithering through the water, fish don't look anthropomorphic; they're just ingredients for bouillabaisse. These two probably don't like the beach much; one's just been run over by a car, the other seems to be sticking out its tongue in a final desperate act. Out of context, dead in our air with their heads severed, before their eyes milk over . . . they have faces, expressions. That can be scary.

Maybe that's why the Mafia leaves a dead fish rolled up in your morning news-paper when you're on the hit list; that gaping mouth, those staring eyes—that's the future. I can't stand fishing, because of that unpleasant moment when the fish is caught, and starts squiggling. When my eldest son was very young, I was able to fool him by putting only a weight on our lines, no hook. Finally, when he noticed that everyone around us was catching fish right and left, he saw the light and was very angry. I told him that my technique was to hit the fish on the head with the weight, but he didn't bite.

Thirty years later, he still remembers, but he says he's not angry any more. Like everyone else in my family, he feels closest to the rest of us on weekends and during vacations at the beach. Just recently, in Mexico, my 14-year-old daugh-ter was using her first camera to photograph beach scenes. She stopped every now and then and looked westward over the Pacific, and I thought of my father, now in his 90s, who used to look out over the Adriatic, when I was a child, dream-ing the one unachieved dream of his life, the vision of going away to sea . . . with all that dream meant, and may still mean, to him. I don't share *his* dream, but I share the dream. I keep looking at the sea.

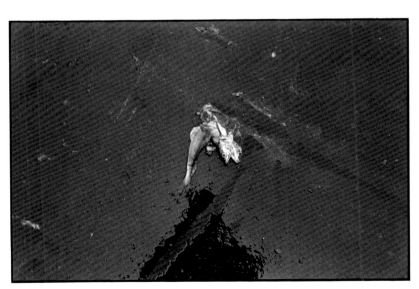

New York, New York, 1953

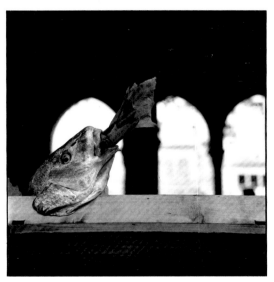

Venice, Italy 1949

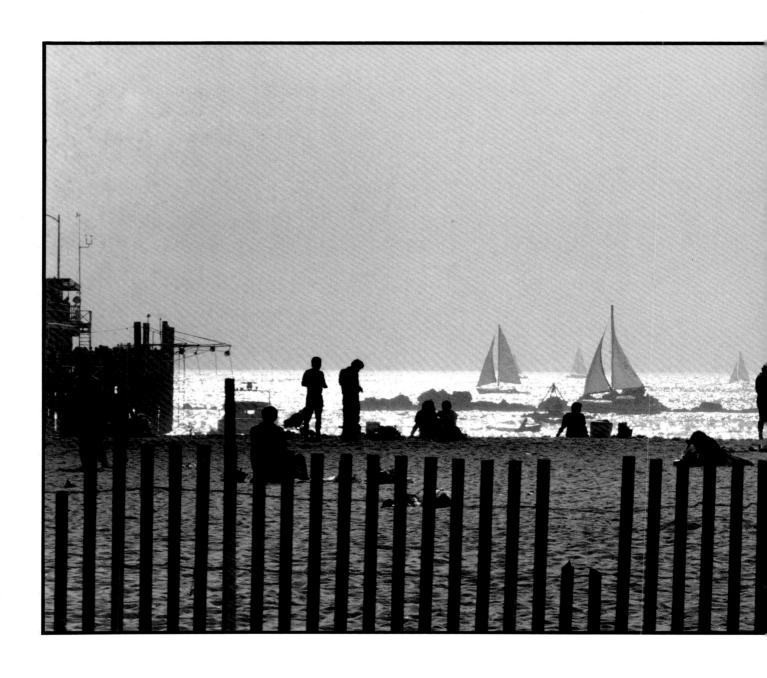

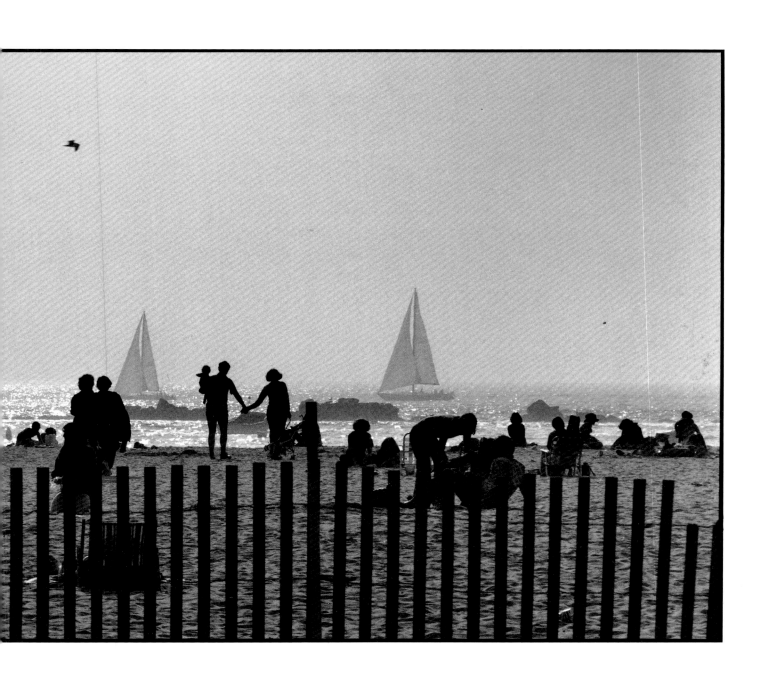

31 | **Santa Monica, California, 1977**

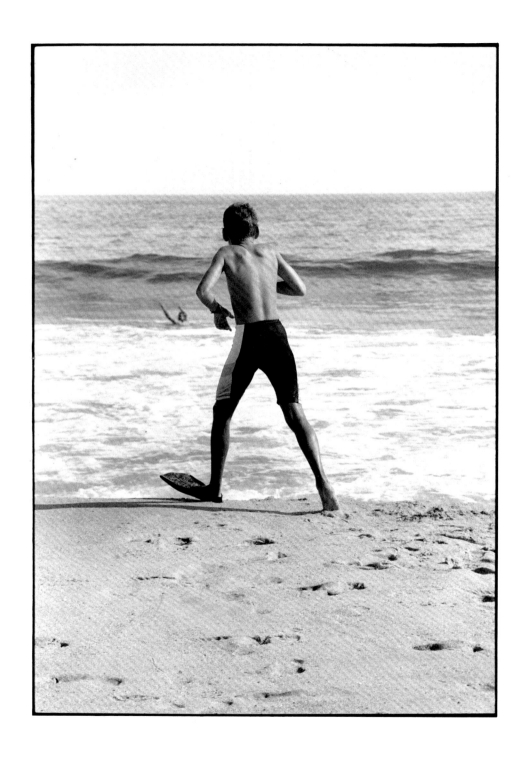

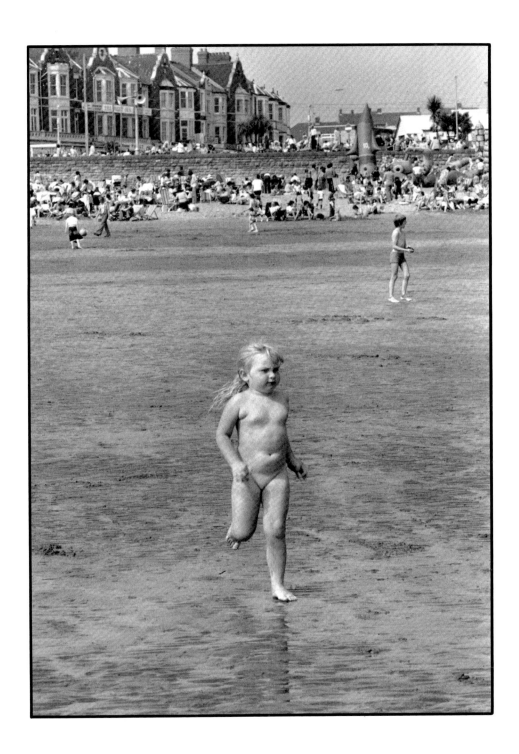

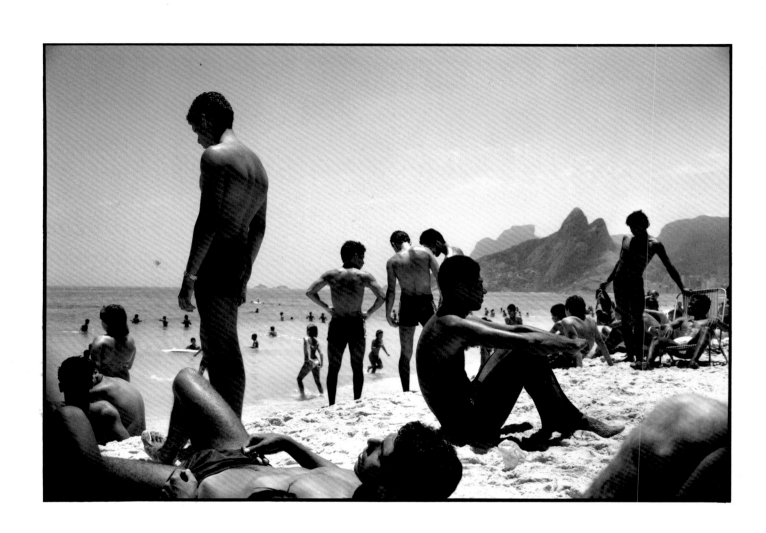

34 | Rio de Janeiro, 1984

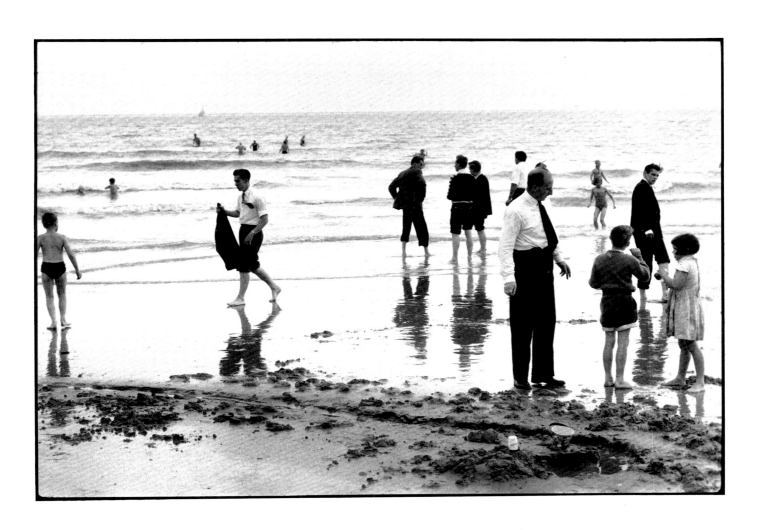

35 | **Brighton, England, 1956**

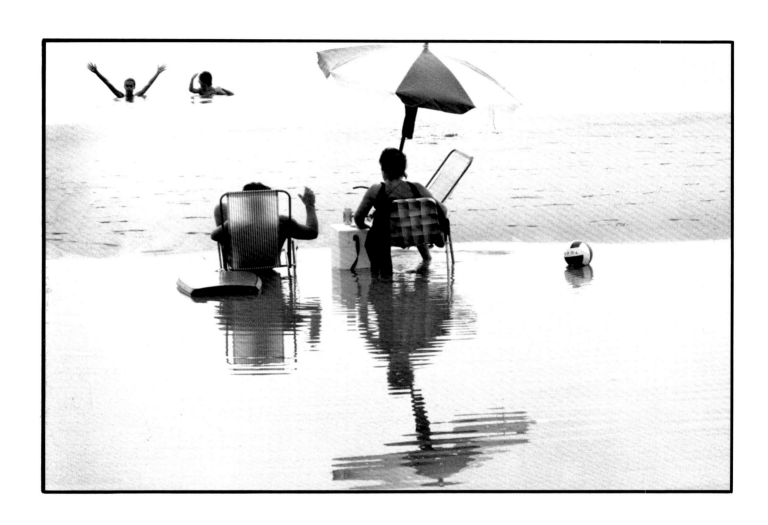

36 | **Rio de Janeiro, 1990**

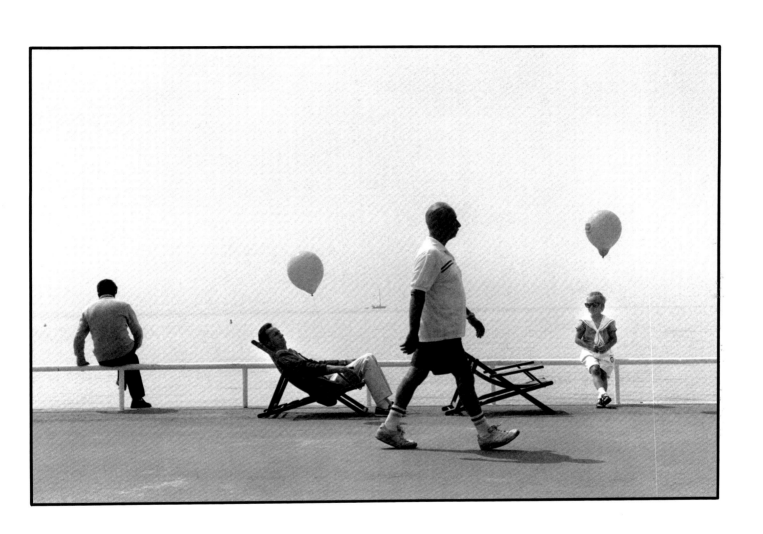

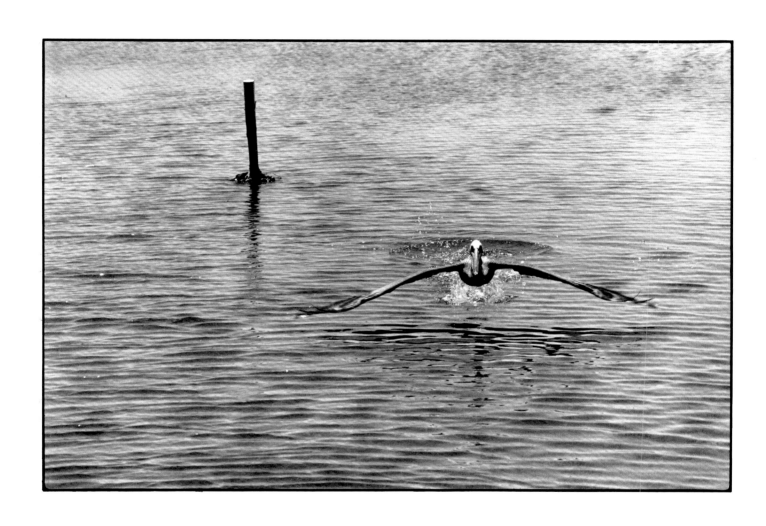

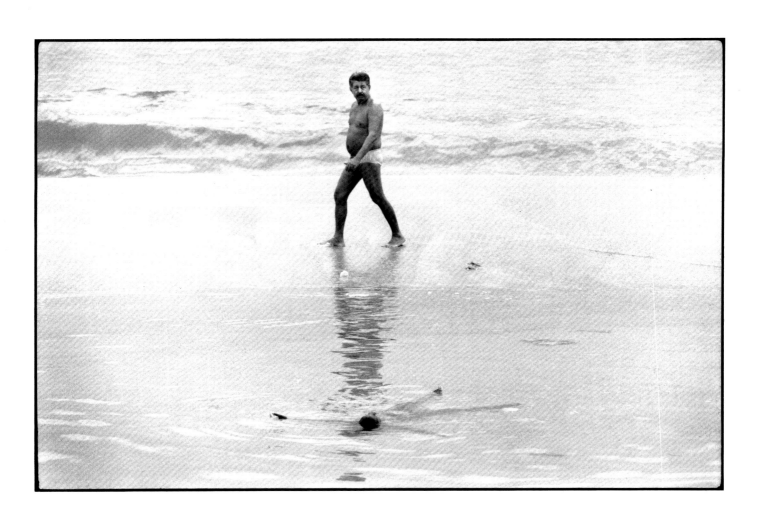

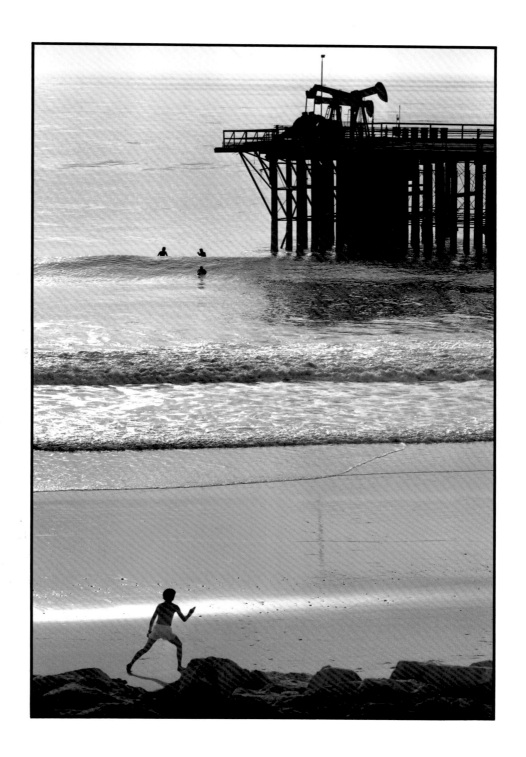

40 | **California, 1977**

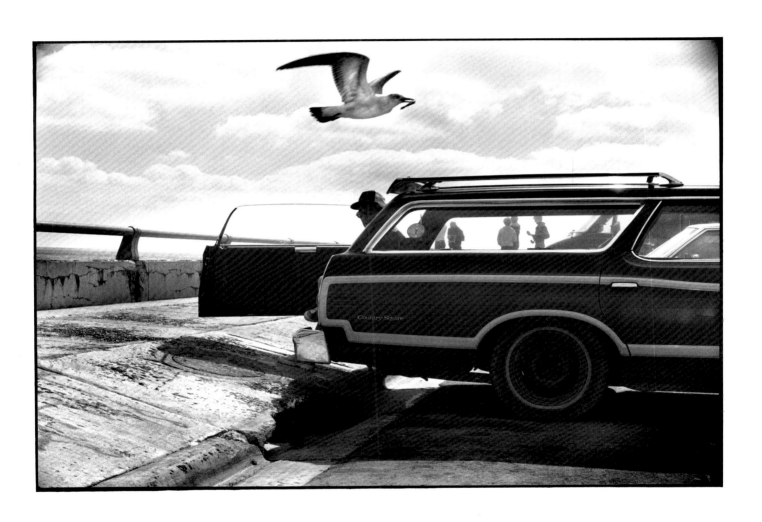

41 | **Key West, Florida, 1980**

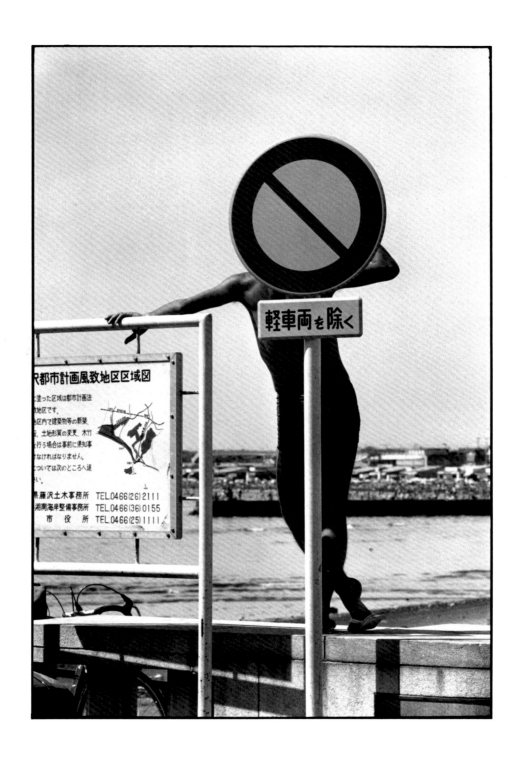

軽車両を除く

R都市計画風致地区区域図

県藤沢土木事務所　TEL 0466(26) 2111
湘南海岸整備事務所　TEL 0466(36) 0155
　　市　役　所　　TEL 0466(25) 1111

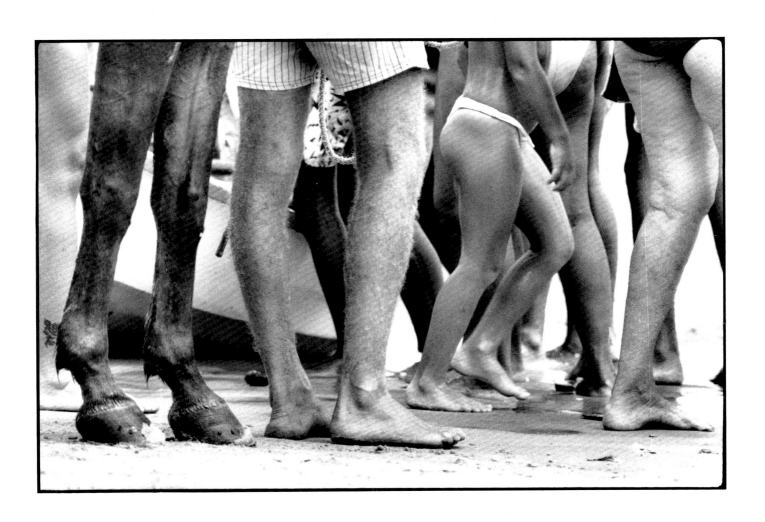

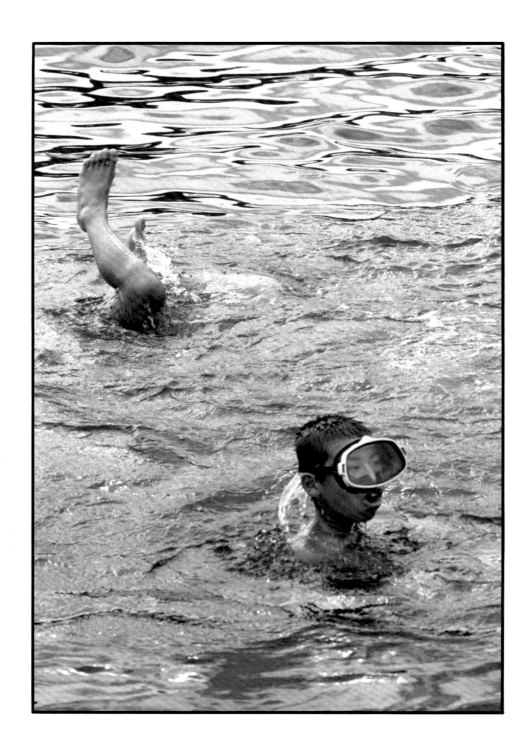

| **Chigasaki, Japan, 1977**

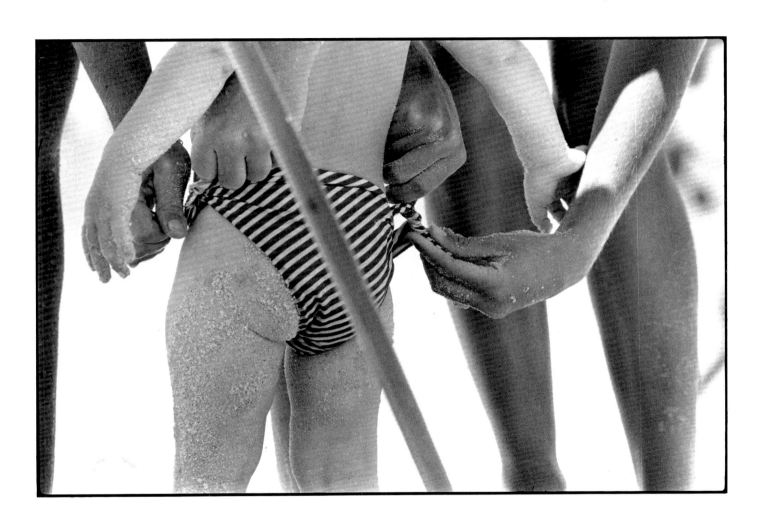

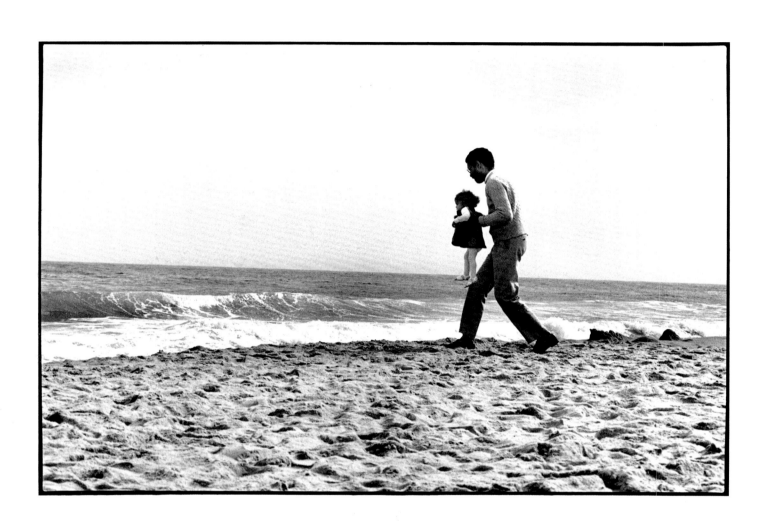

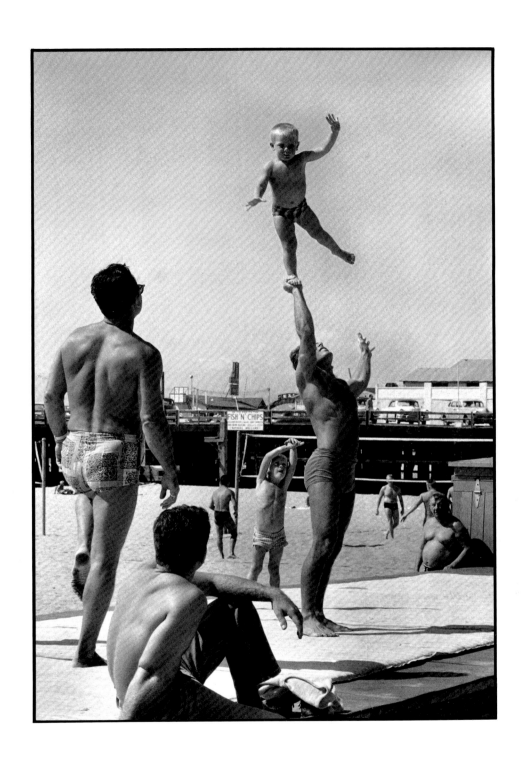

47 | **Venice, California, 1955**

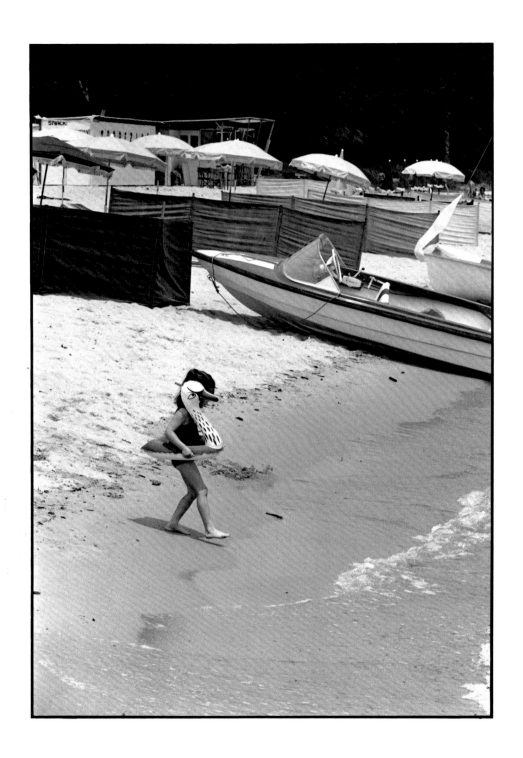

48 | **St. Tropez, France, 1968**

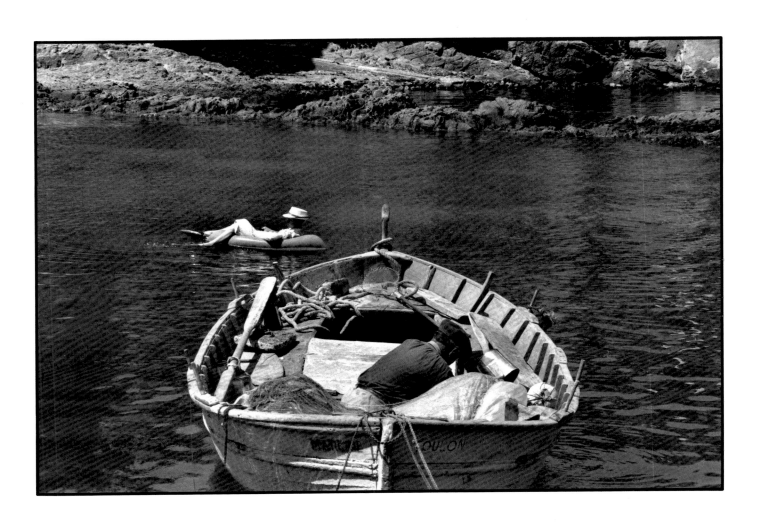

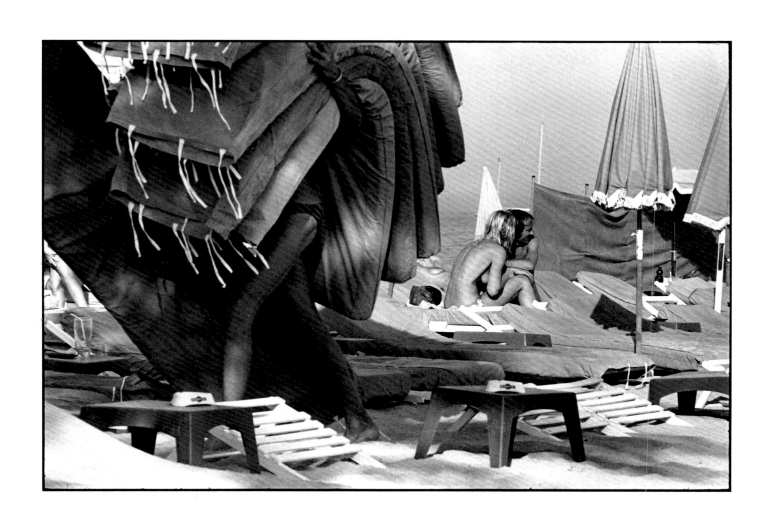

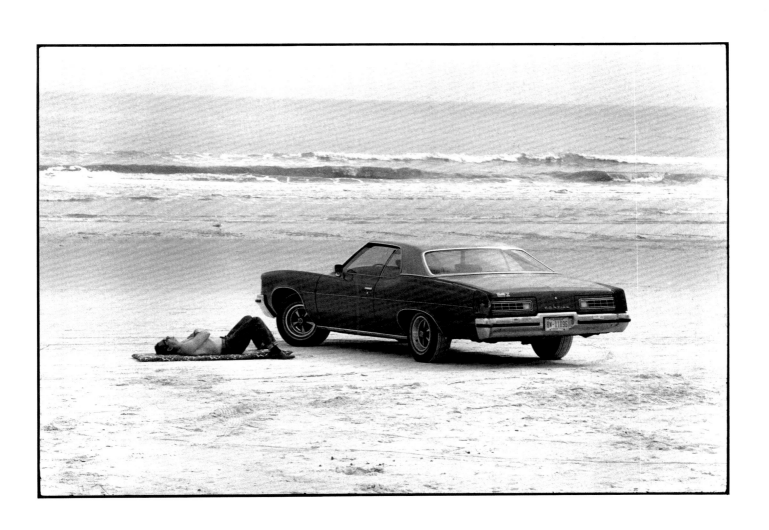

51 | **Daytona Beach, Florida, 1975**

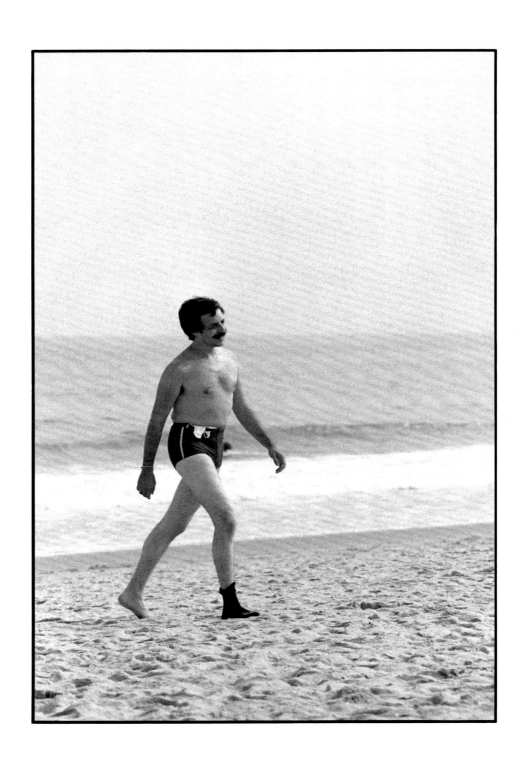

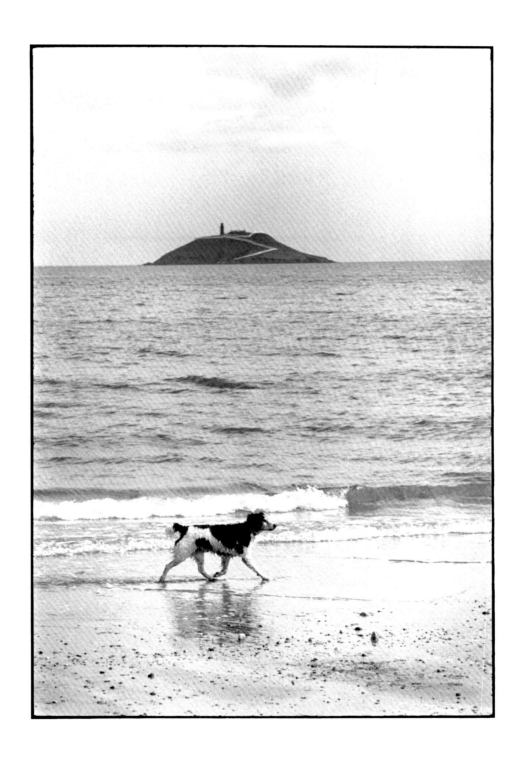

| **Ballycotton, Ireland, 1970** following pages: **Stinson Beach, California, 1975**

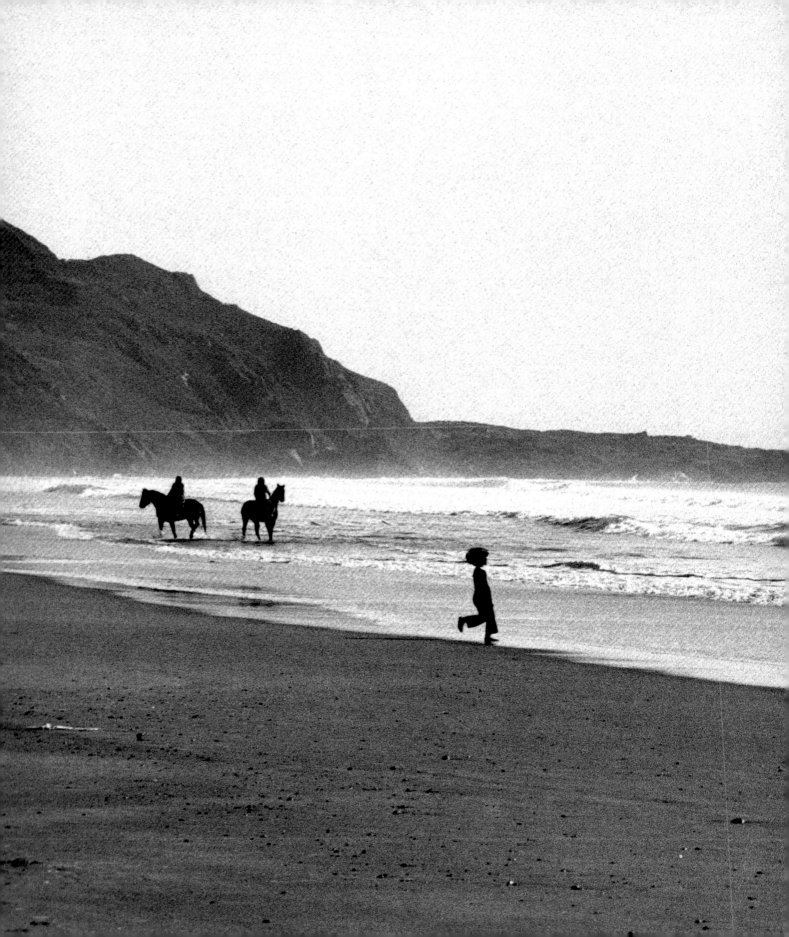

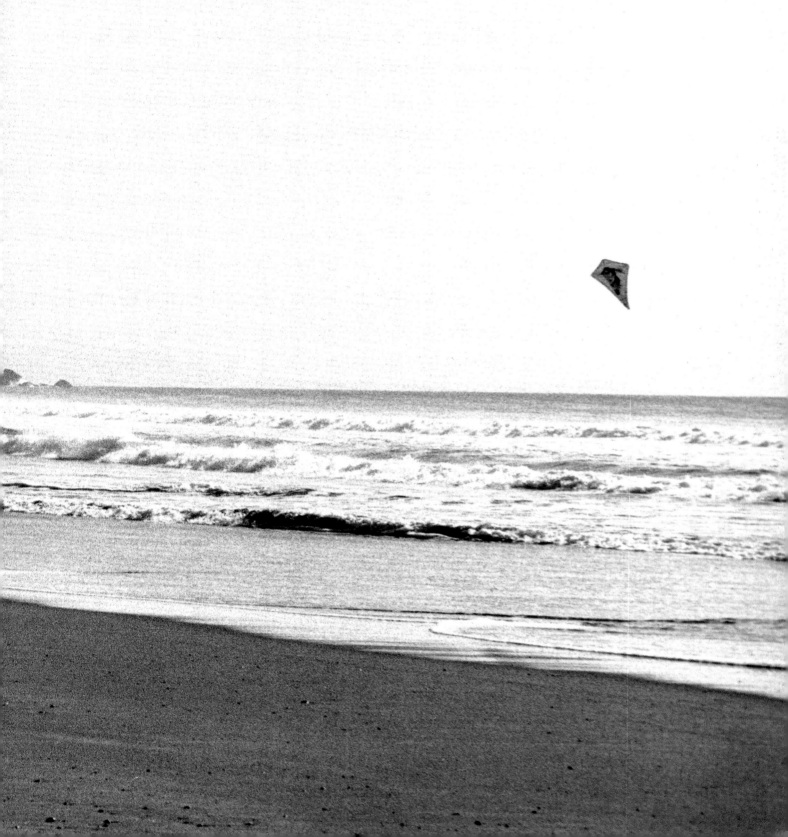

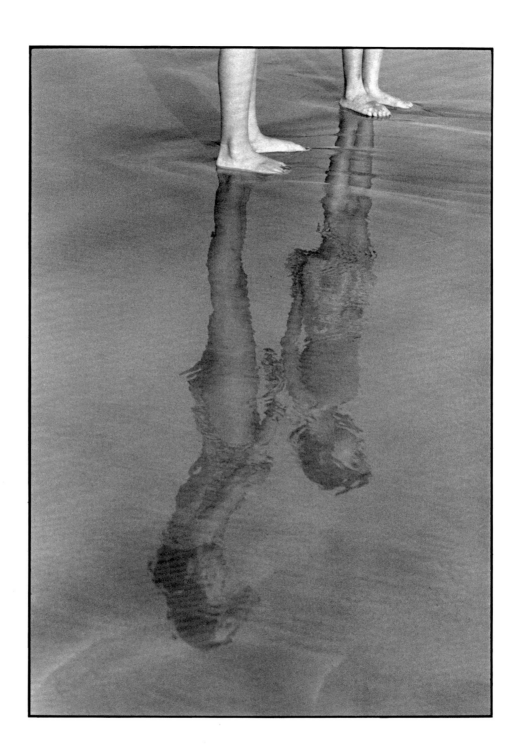

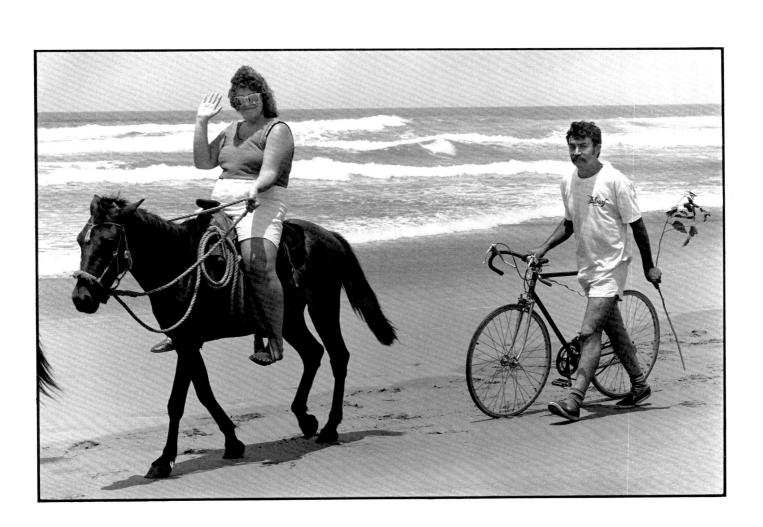

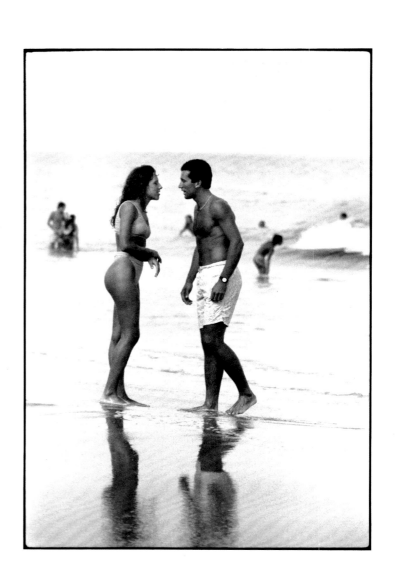

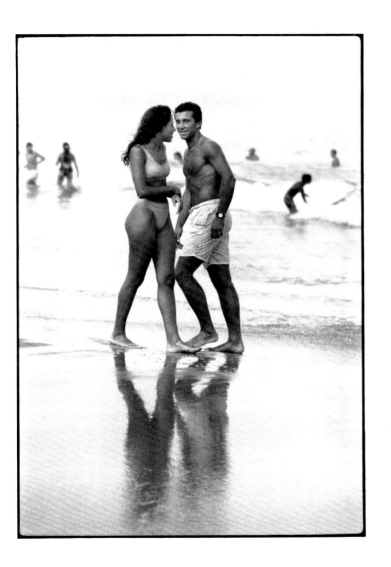

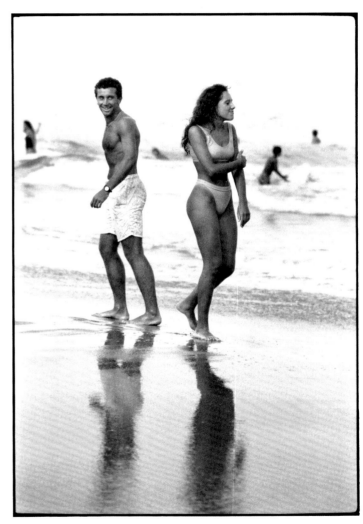

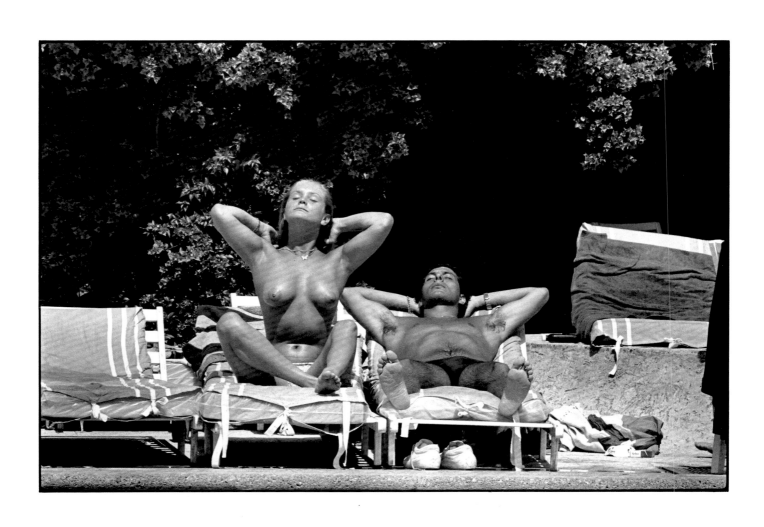

60 St. Tropez, France, 1978

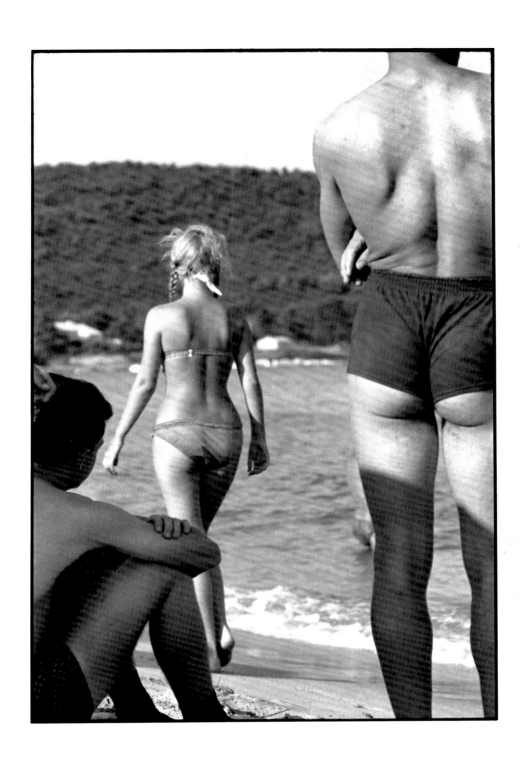

61 | **St. Tropez, France, 1959**

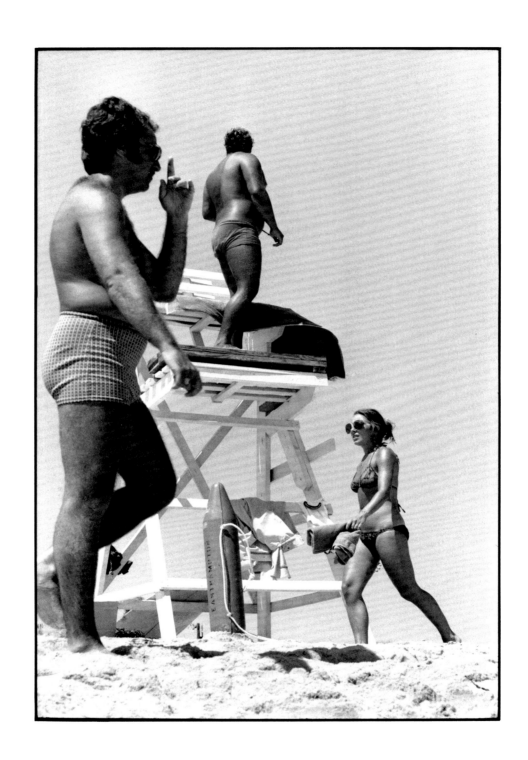

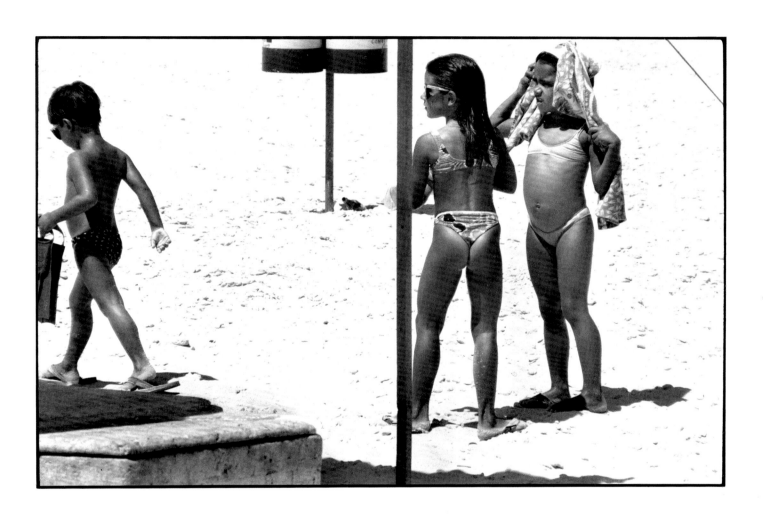

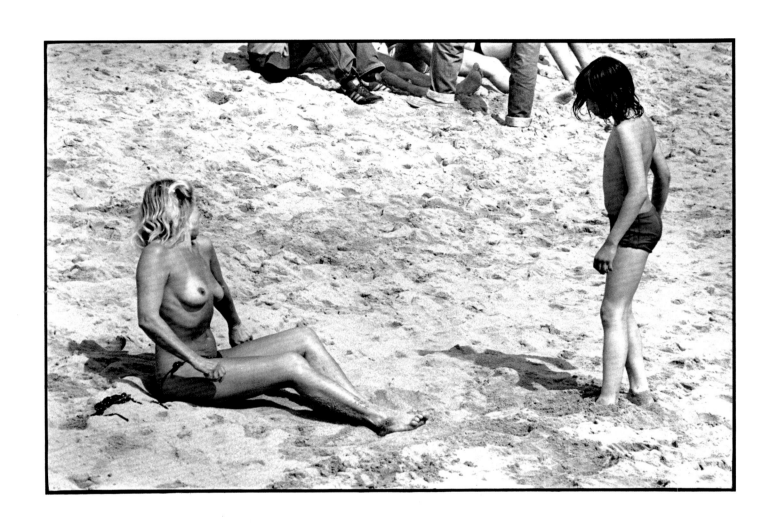

64 | **St. Tropez, France, 1980**

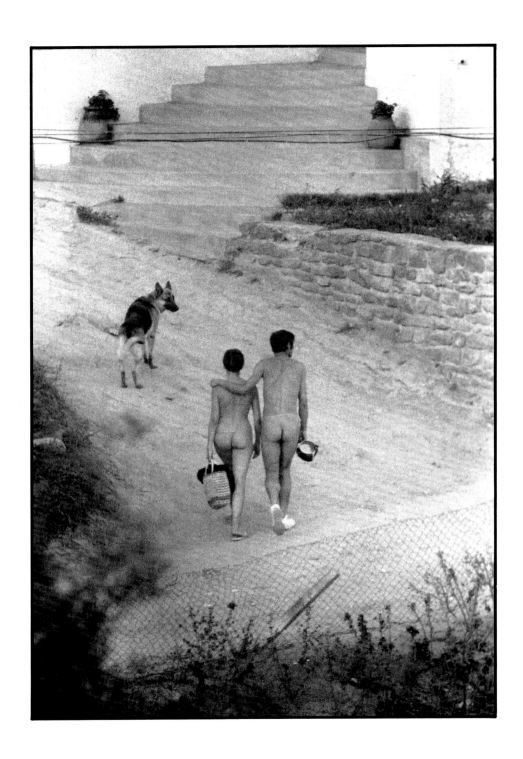

65 | Ile du Levant, France, 1968

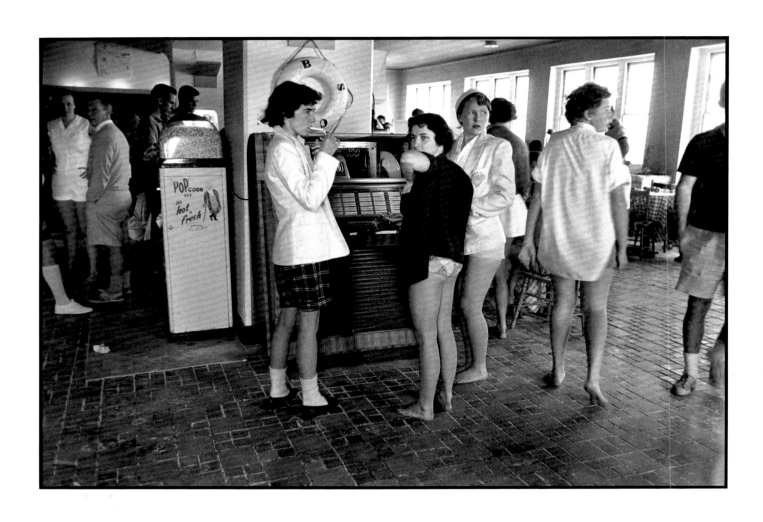

66 | **Hamilton, Bermuda, 1953**

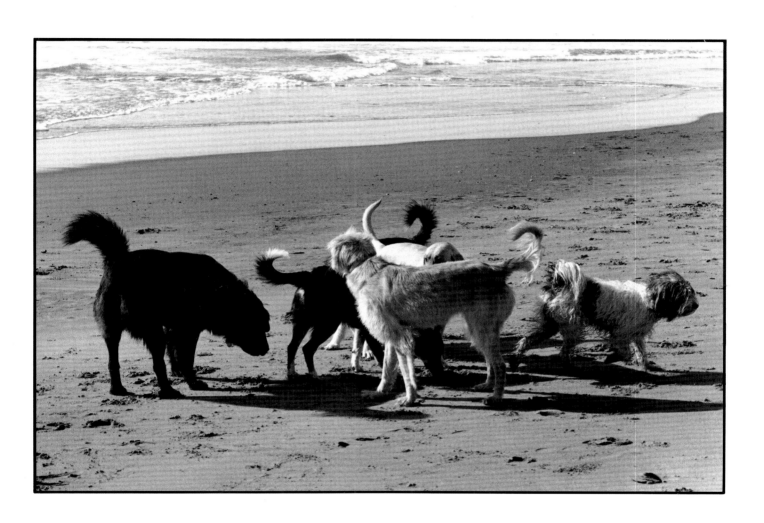

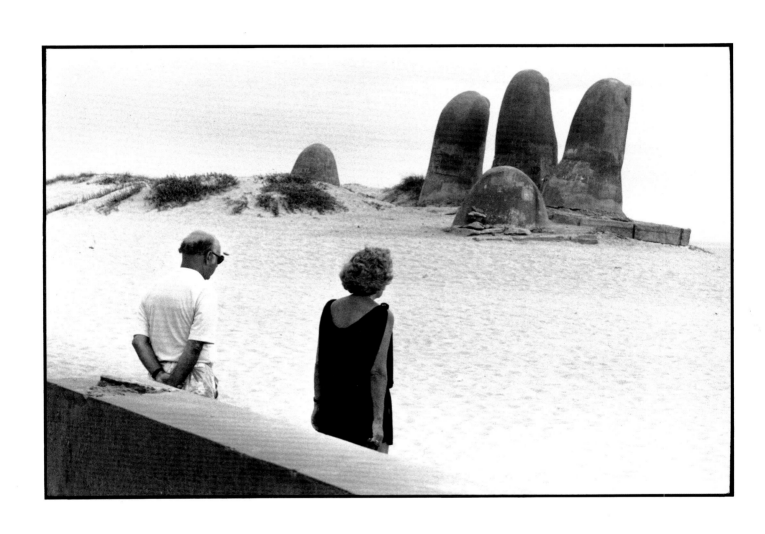

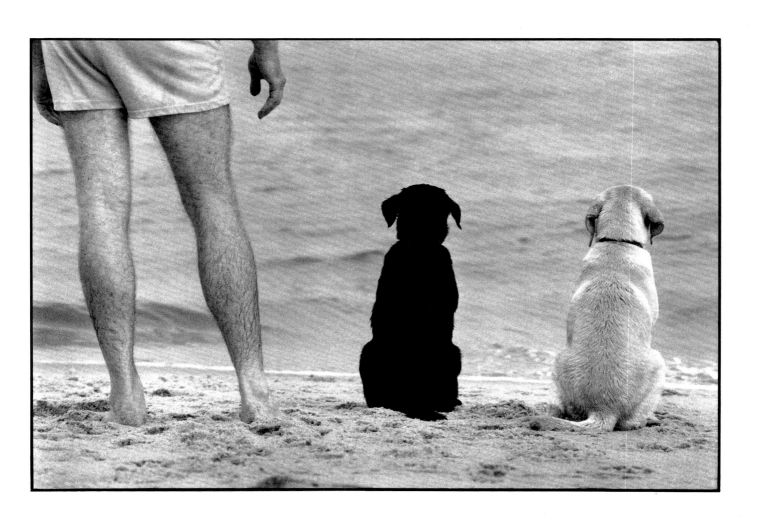

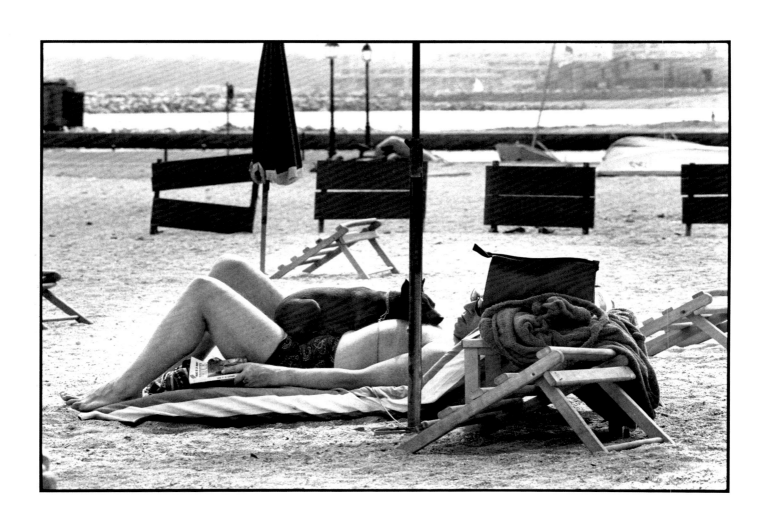

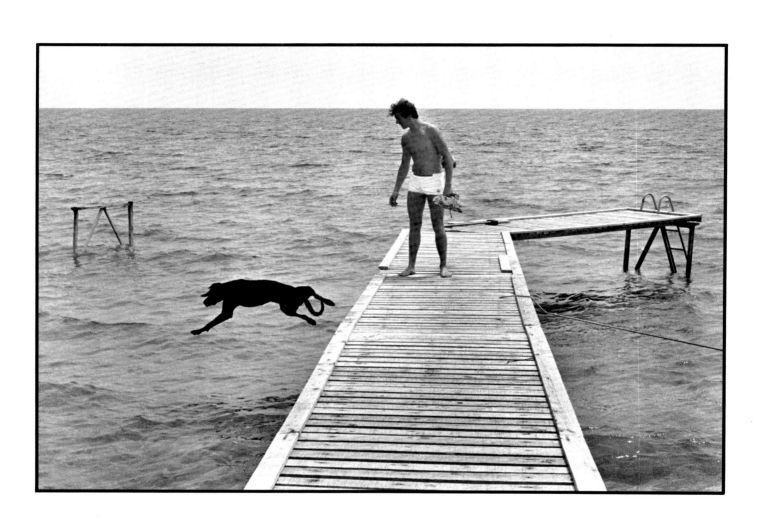

71 | **St. Tropez, France, 1968**

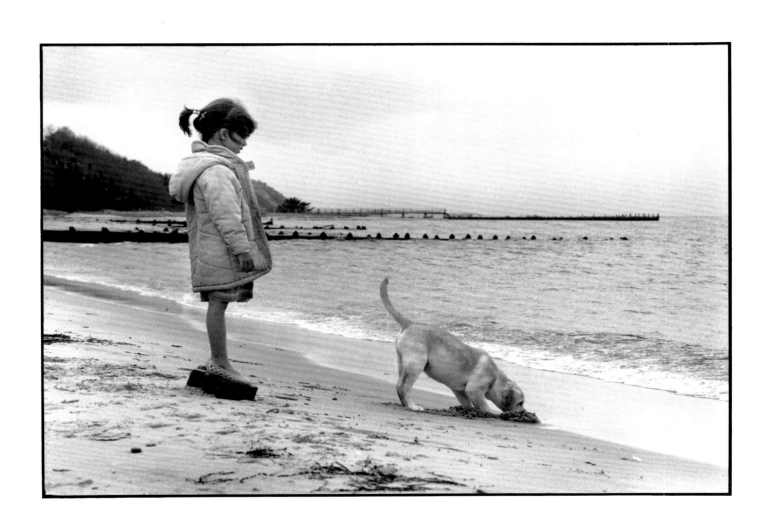

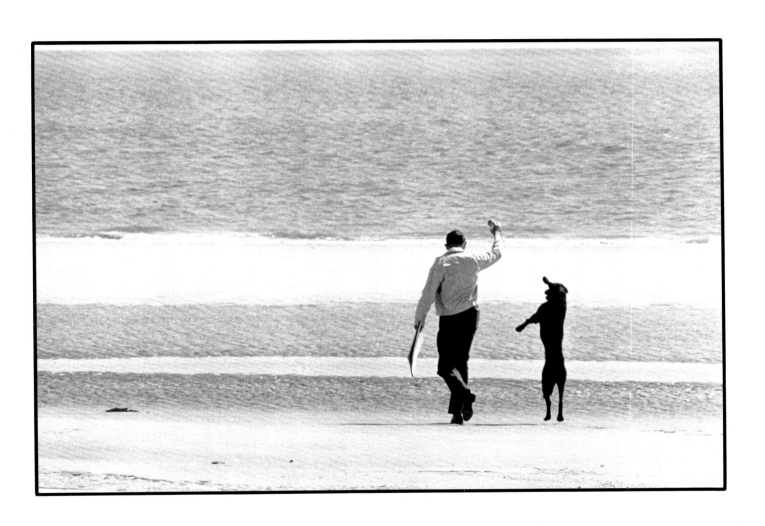

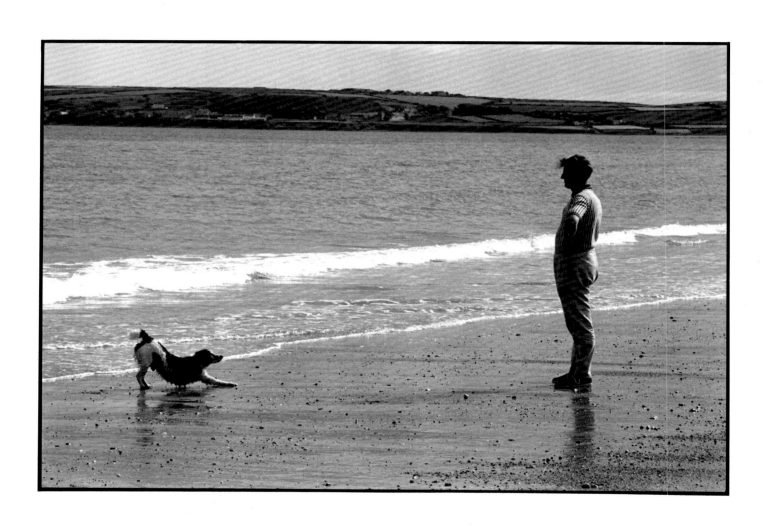

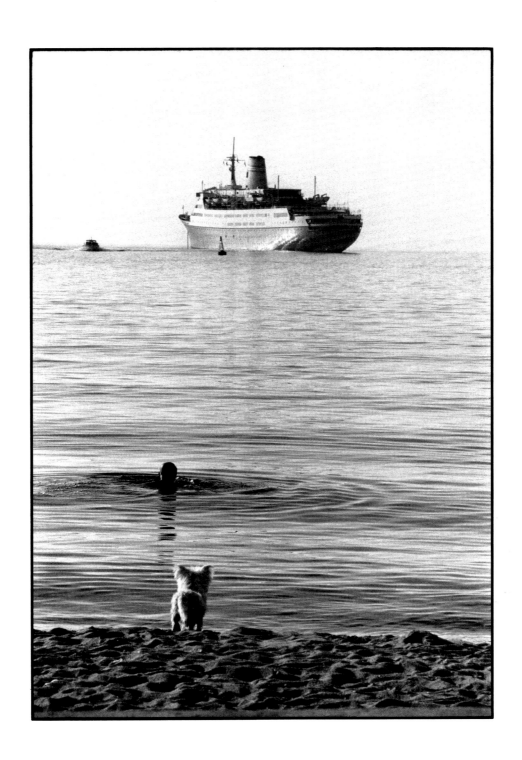

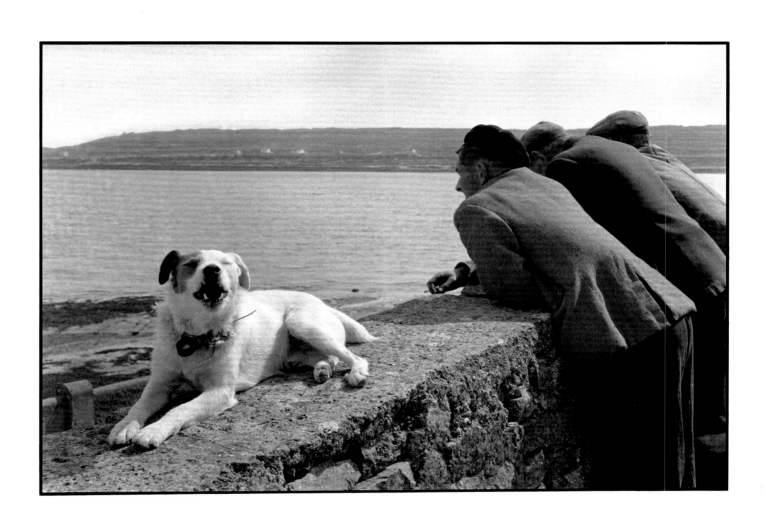

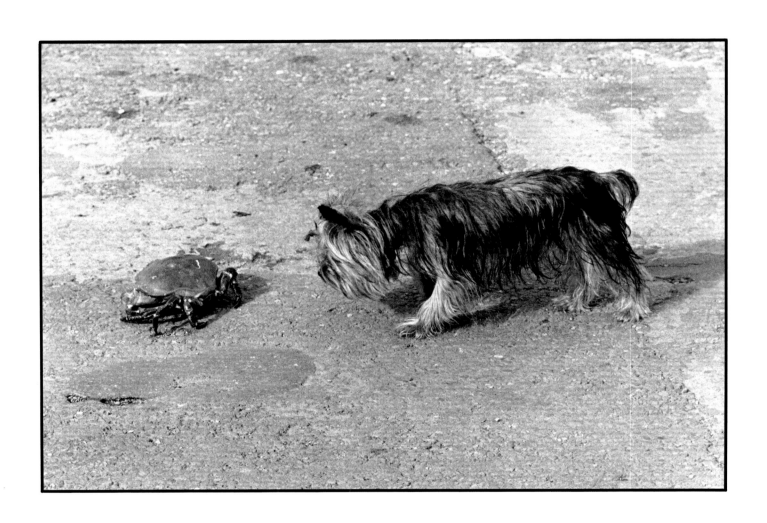

77 | **Ballycotton, Ireland, 1968**

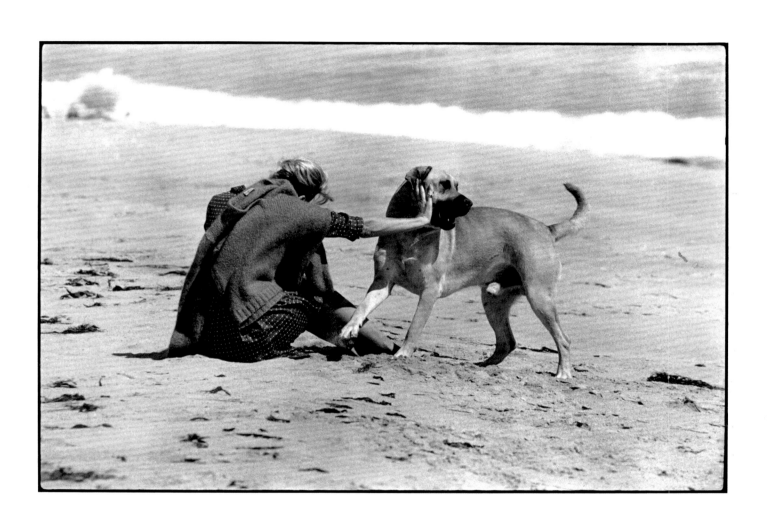

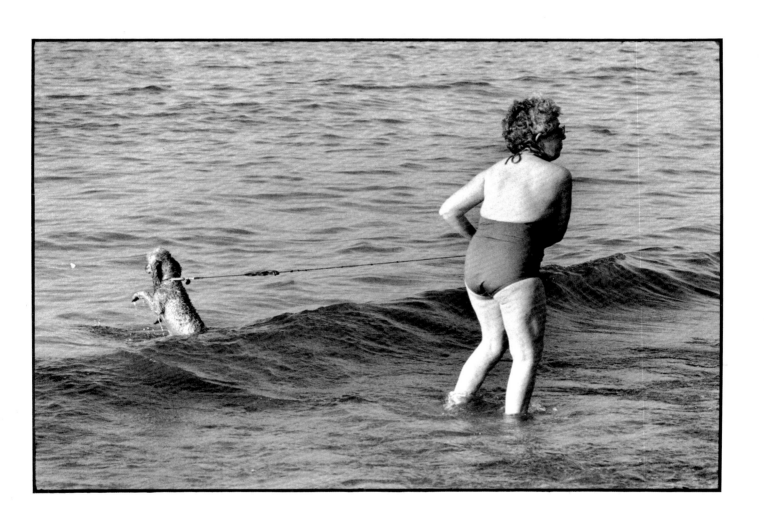

| Calvi, Corsica, 1990

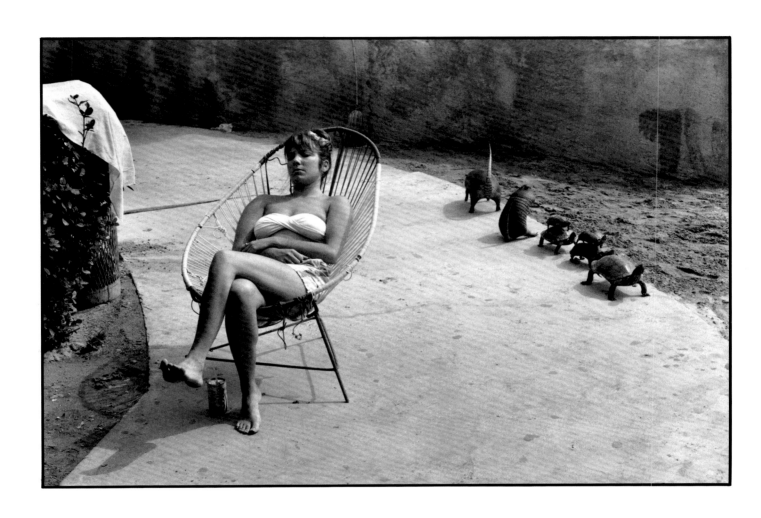

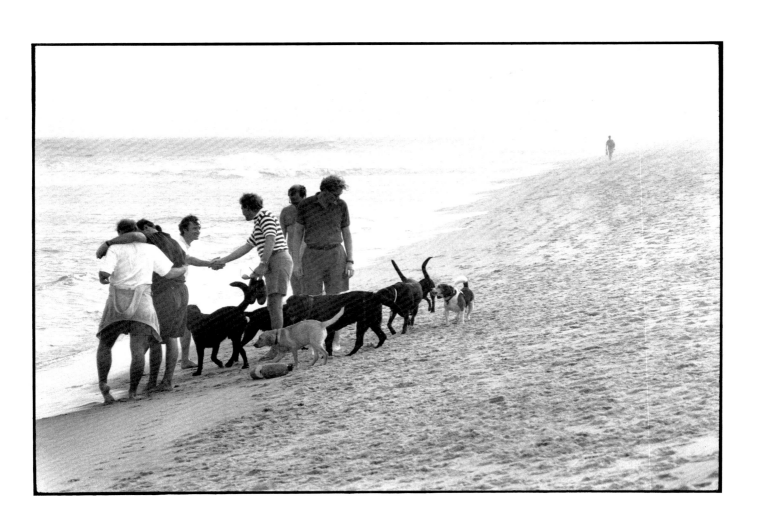

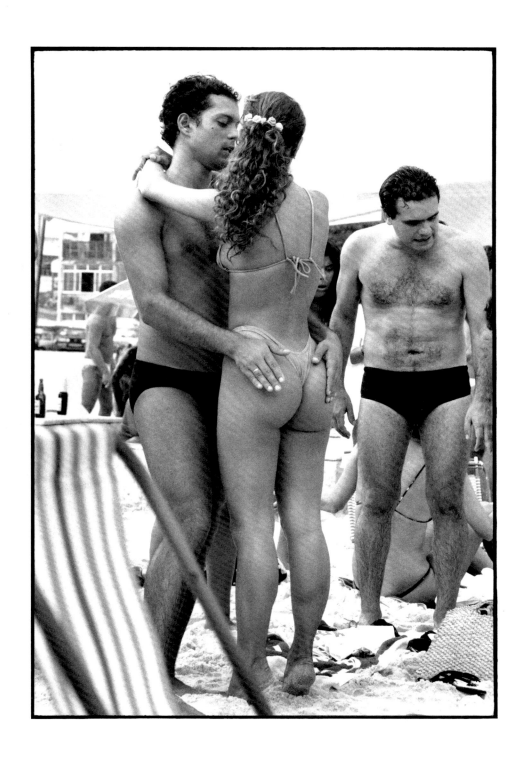

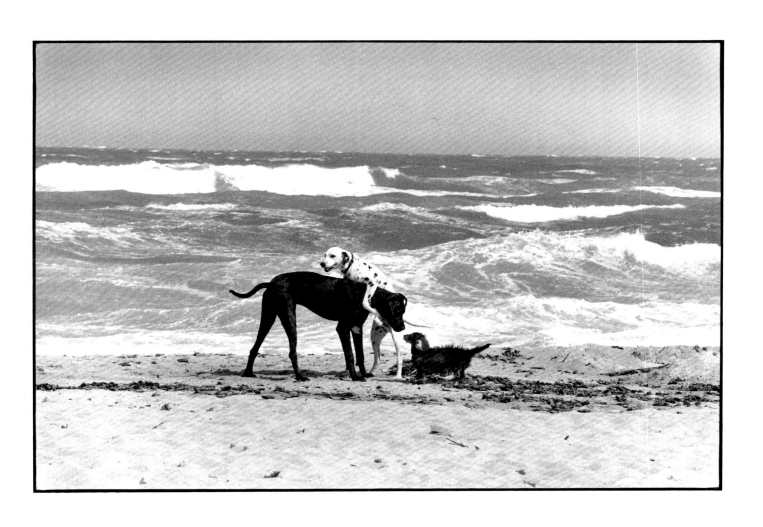

83 | **St. Tropez, France, 1979**

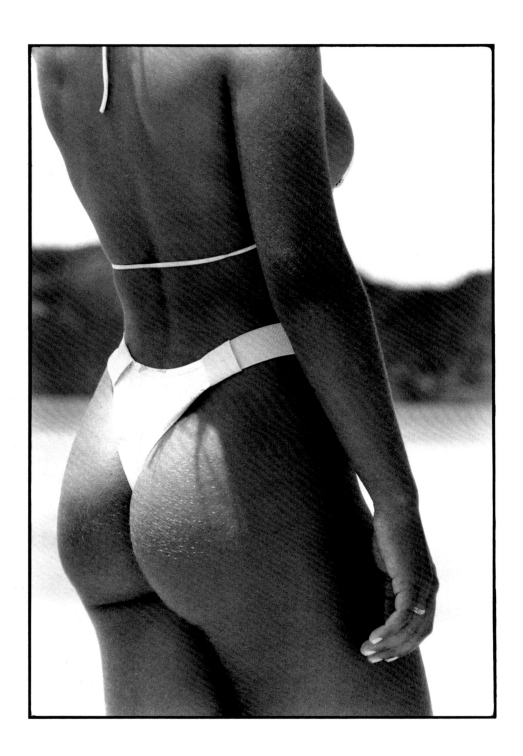

84 | Buzios, Brazil, 1990

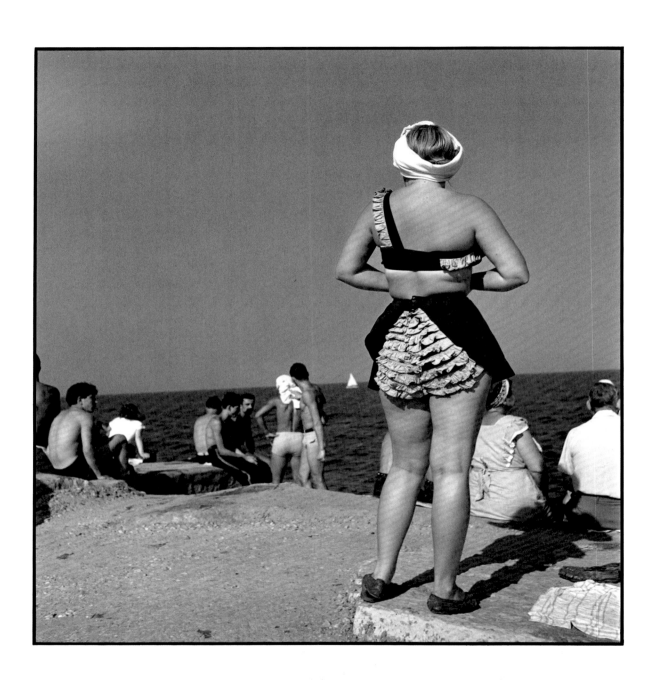

85 | Lake Michigan, U.S.A., 1949

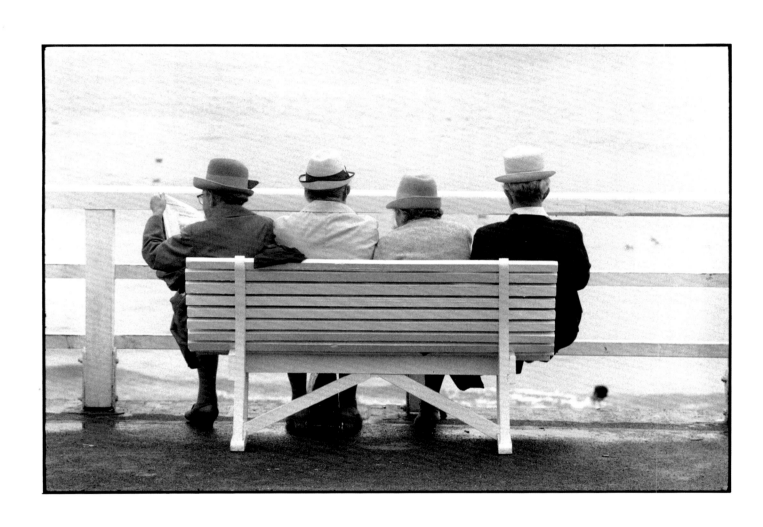

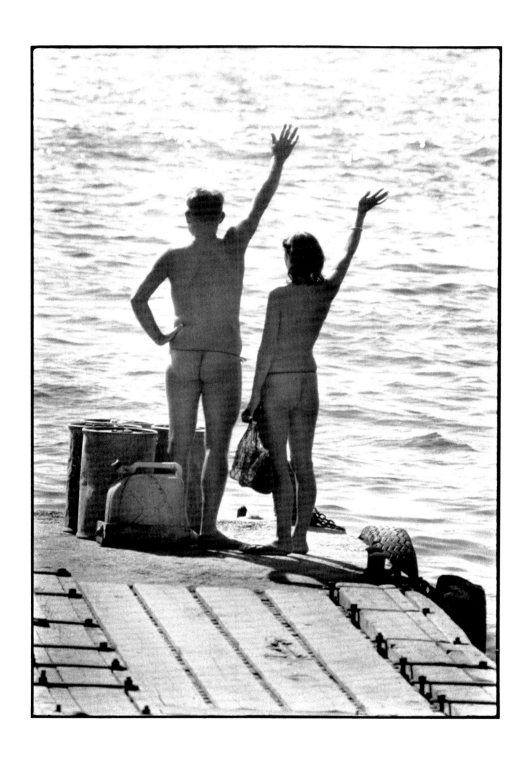

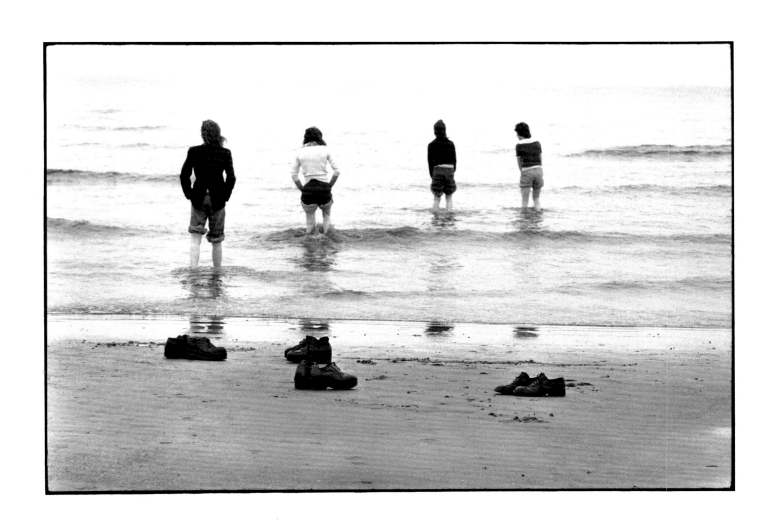

88 | **Blackpool, England, 1975**

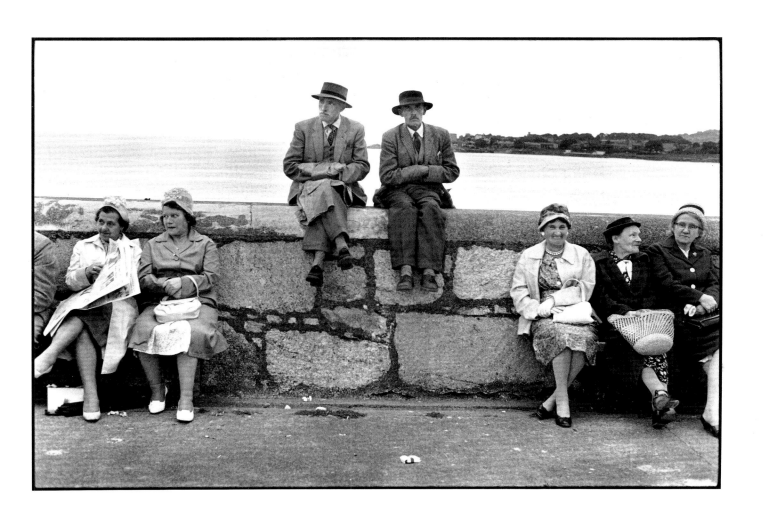

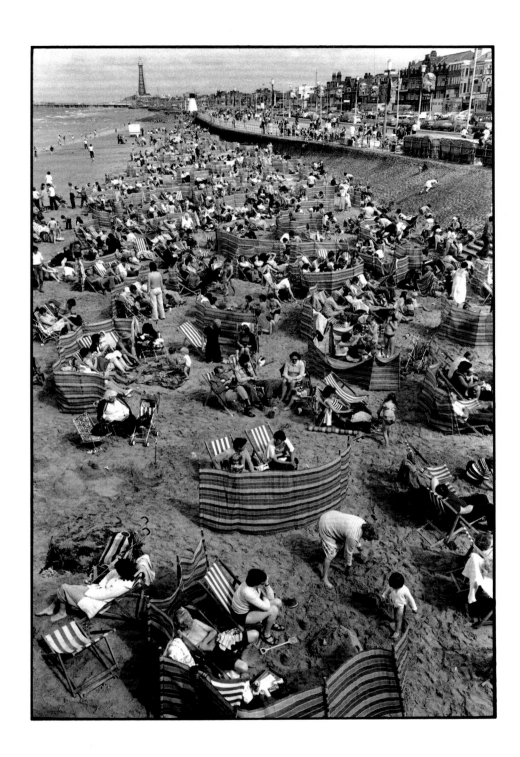

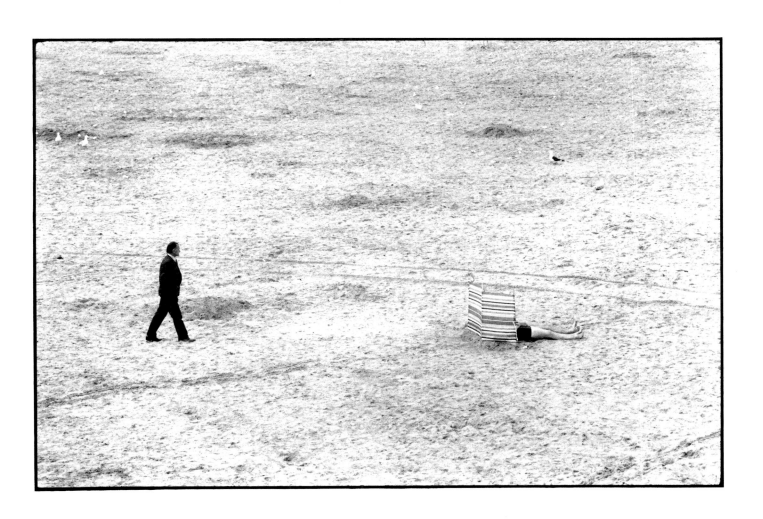

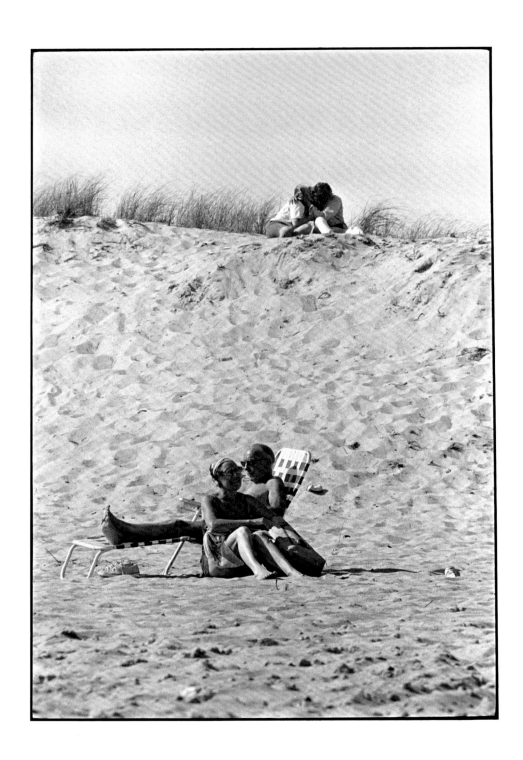

| **Amagansett, New York, 1966**

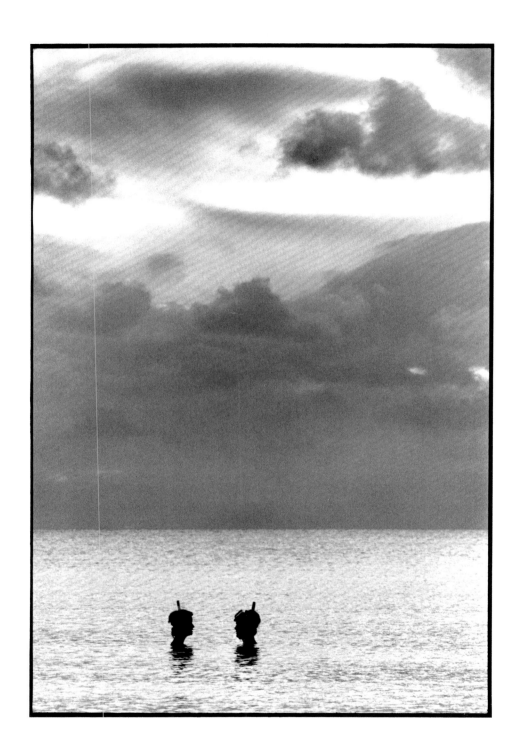

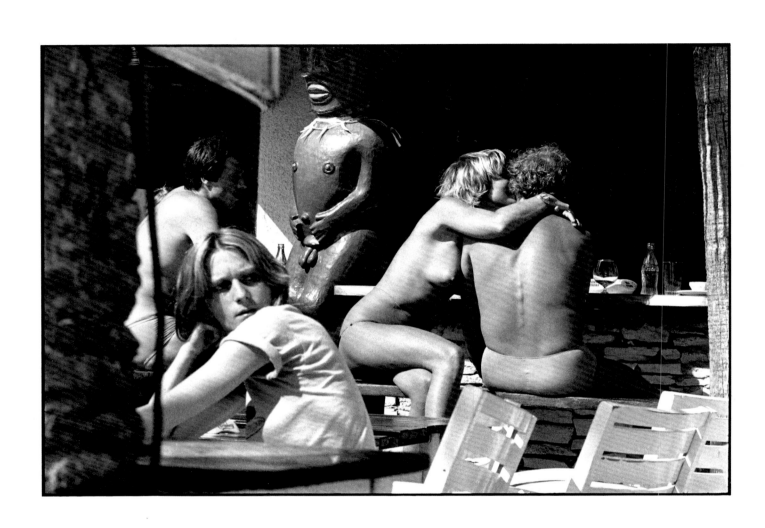

94 | **St. Tropez, France, 1978**

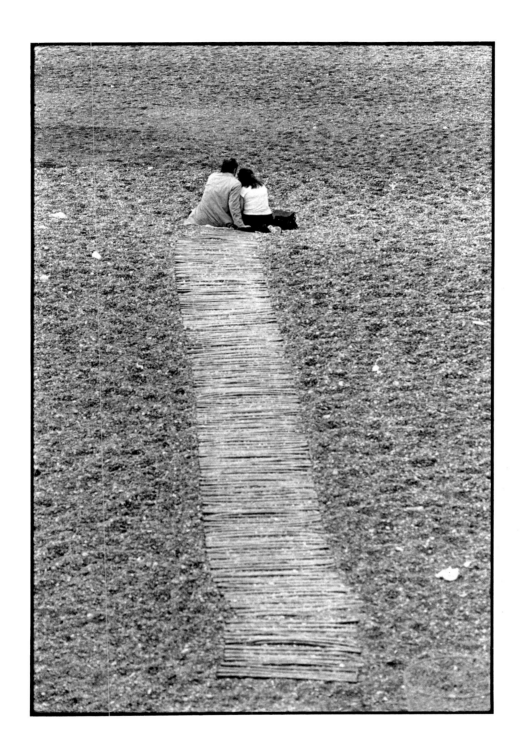

| **Brighton, England, 1966**

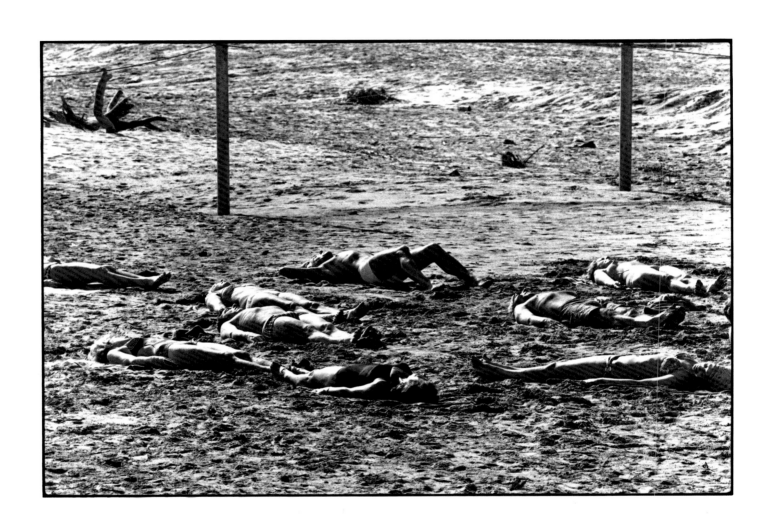

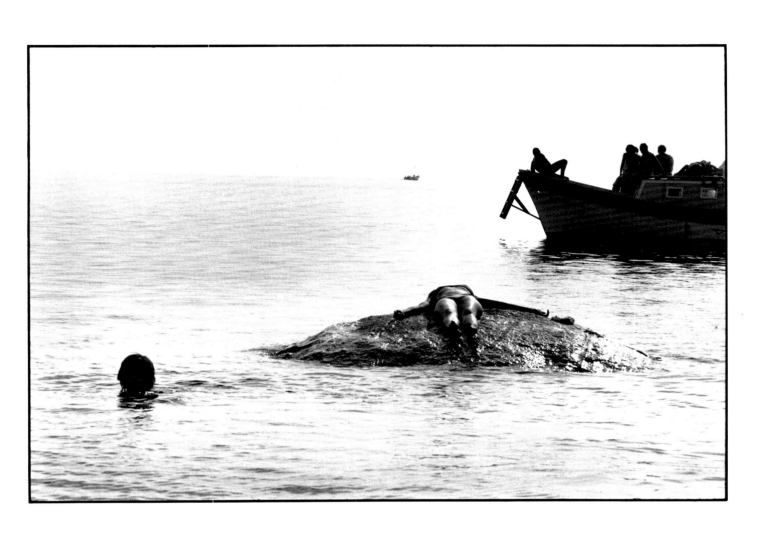

97 | Mikonos, Greece, 1976

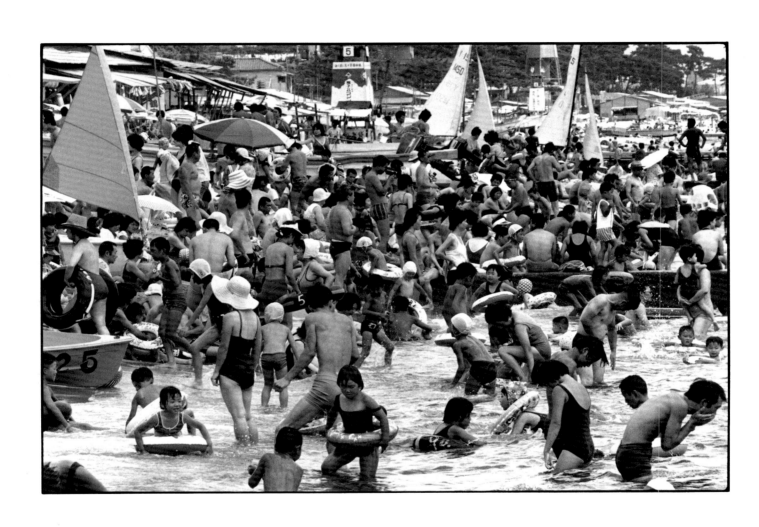

98 | **Fujisawa, Japan, 1977**

99 | Southampton, New York, 1969

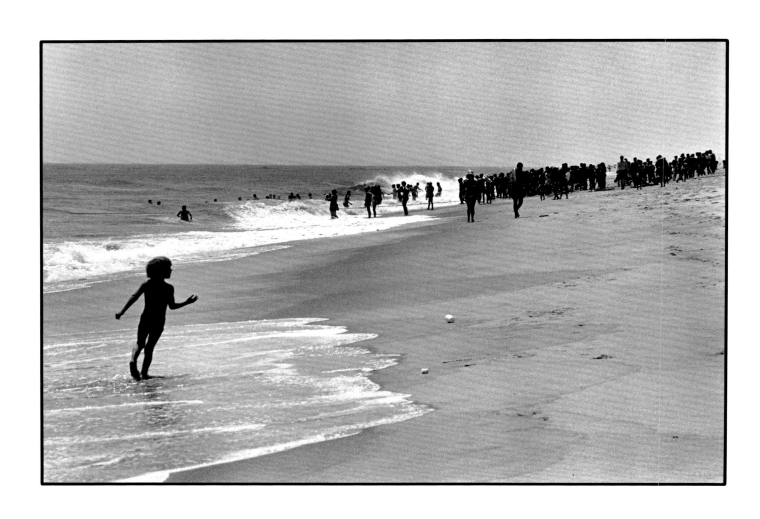

100 | **Amagansett, New York, 1969**

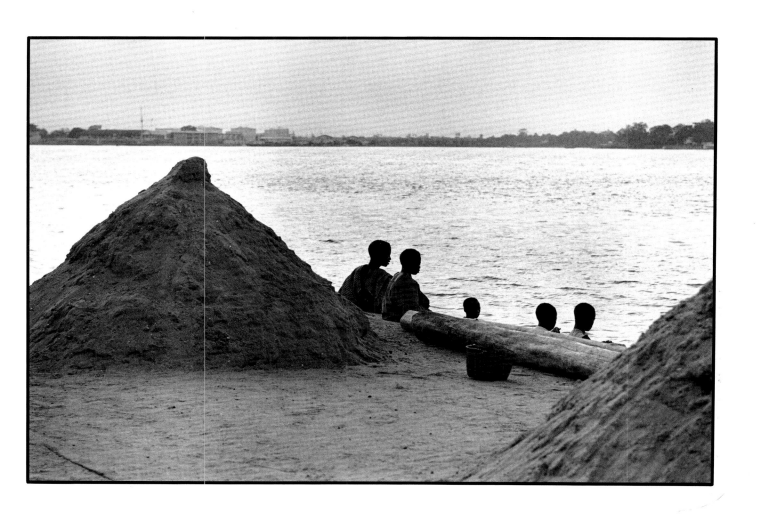

101 | Lagos, Nigeria, 1961

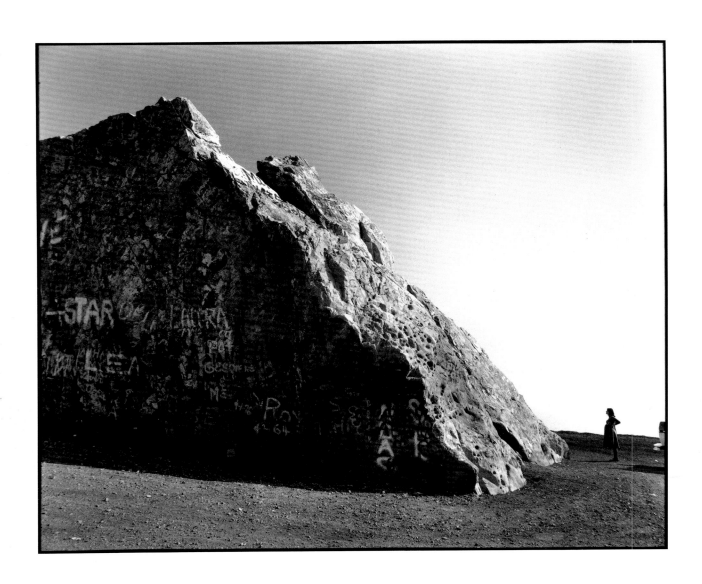

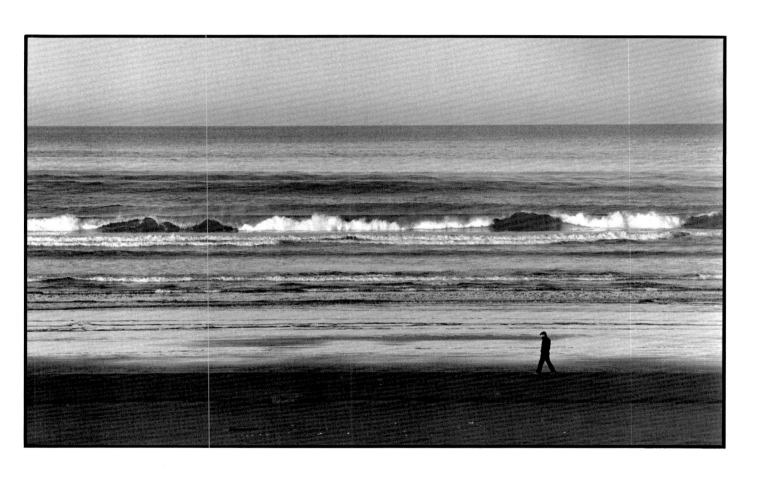

103 Oregon Coast, 1976

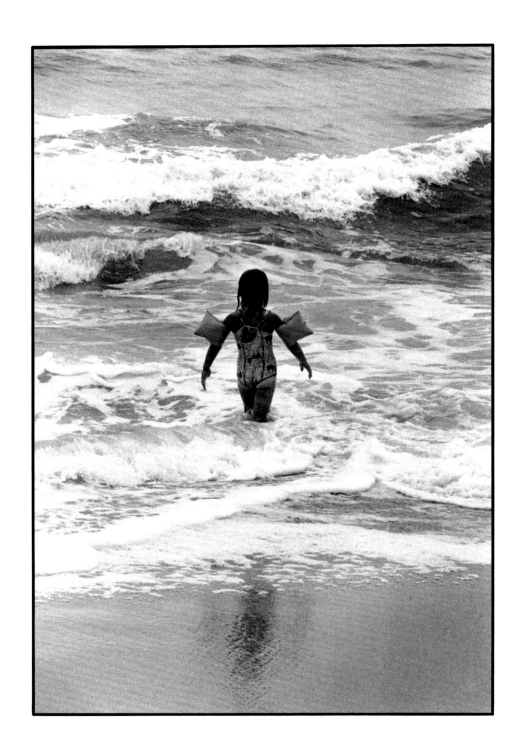

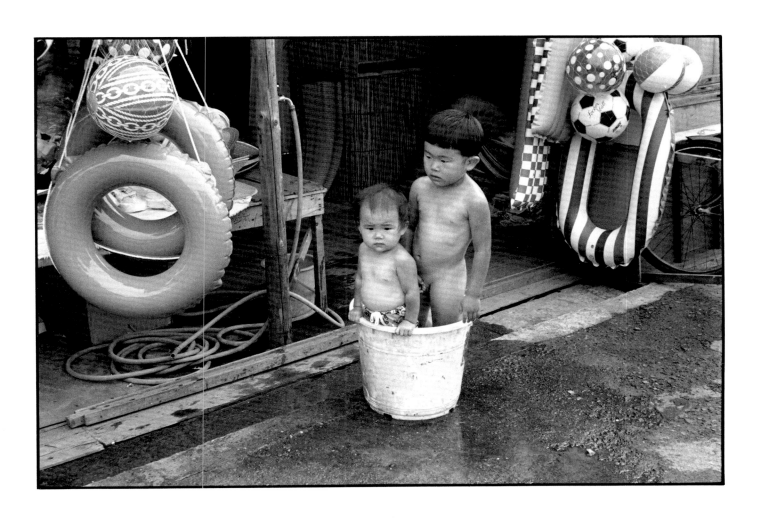

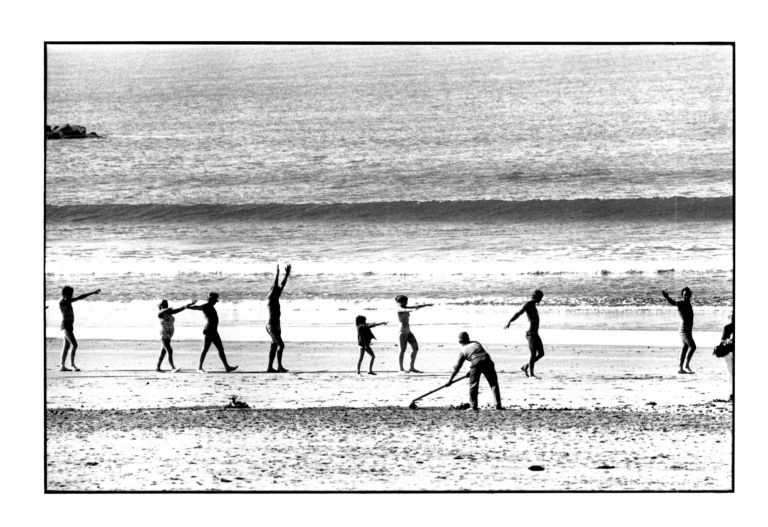

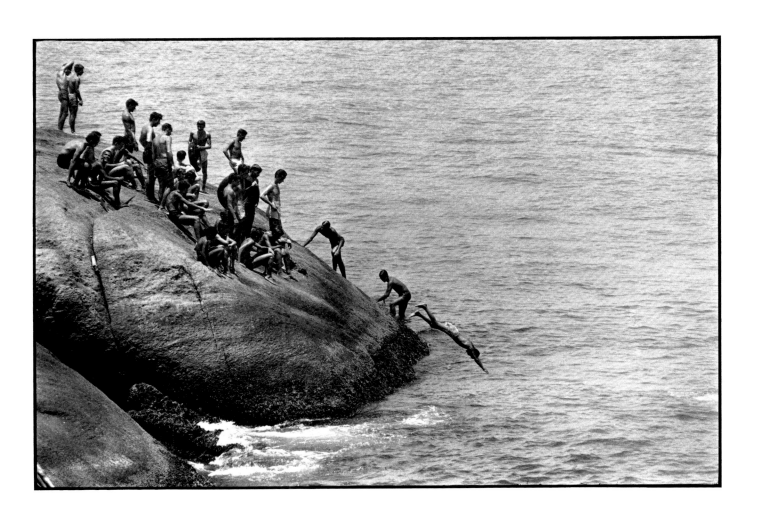

107 Rio de Janeiro, 1963

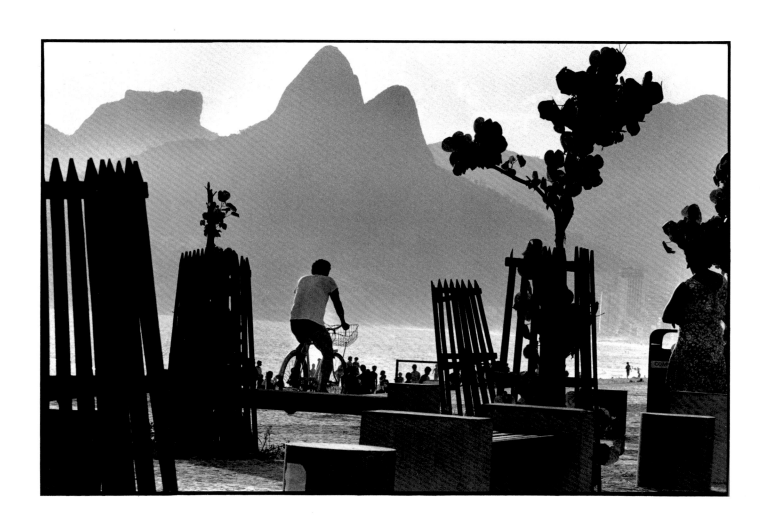

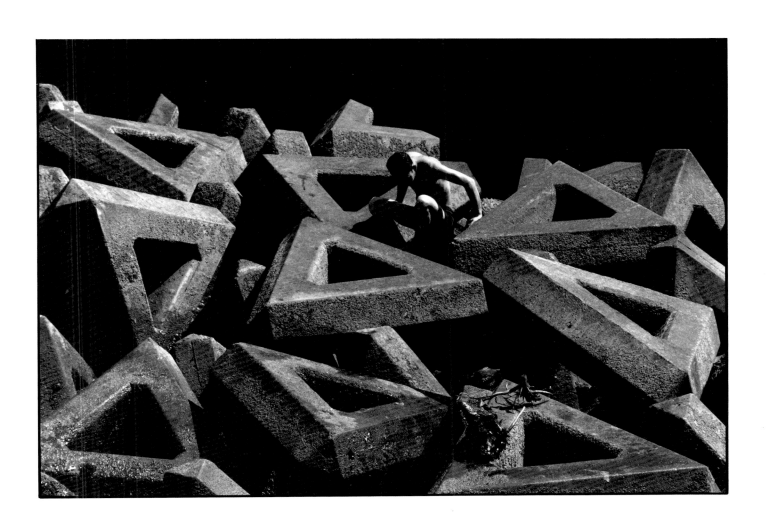

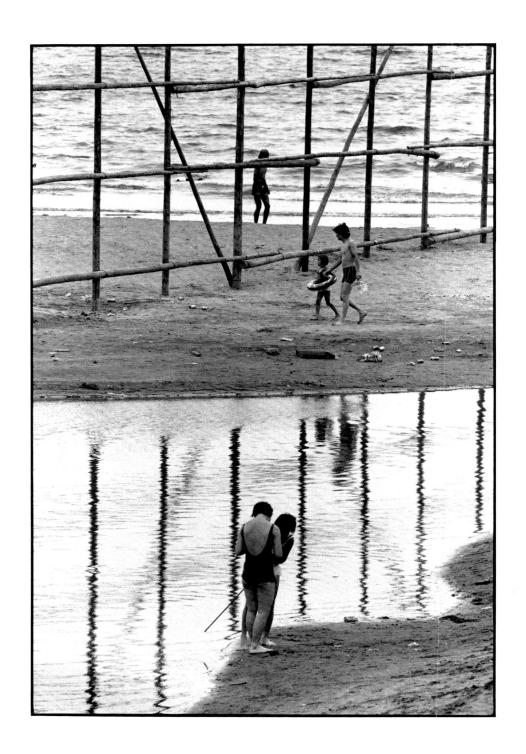

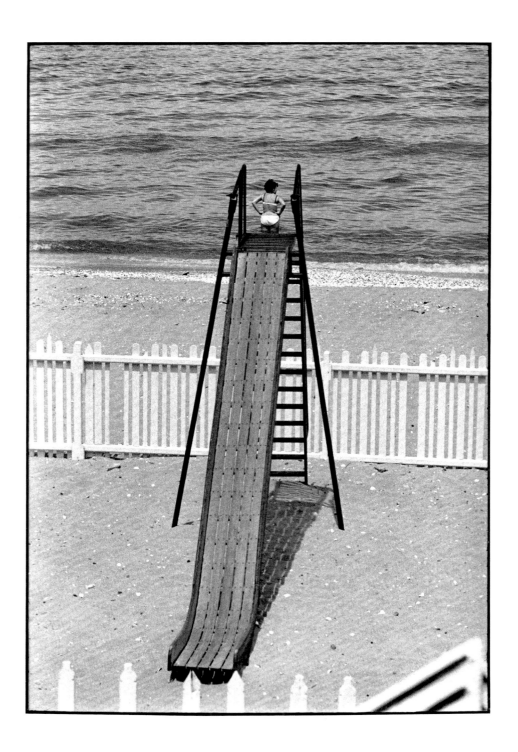

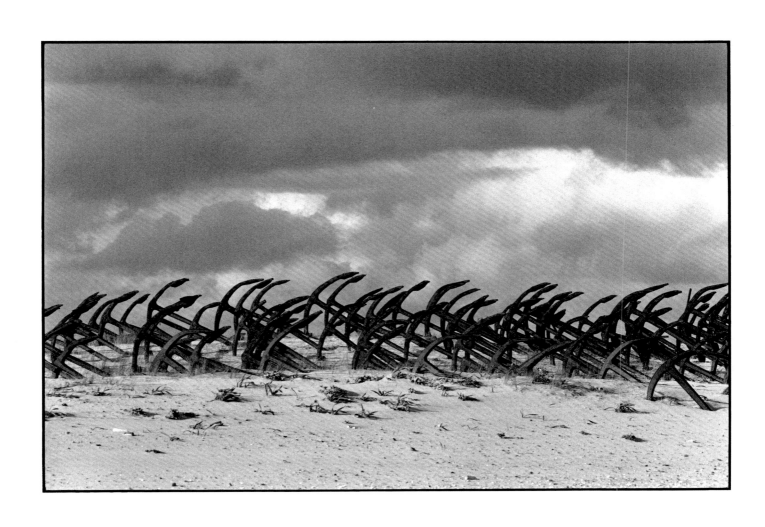

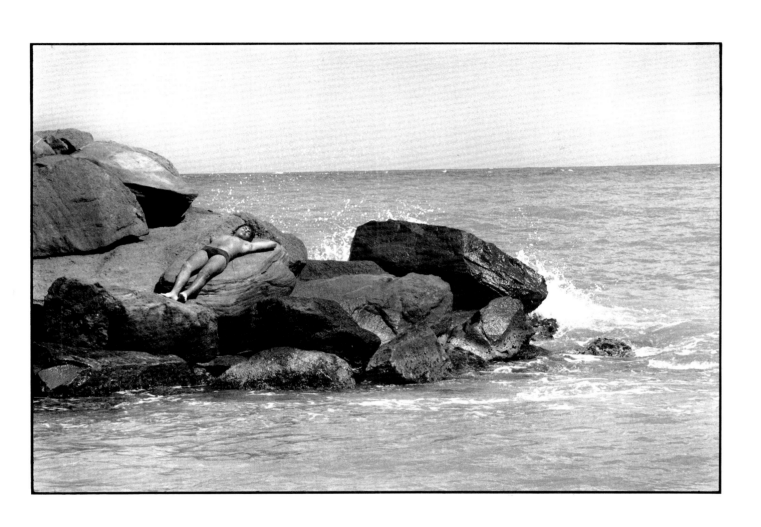

113 | **San Juan, Puerto Rico, 1978**

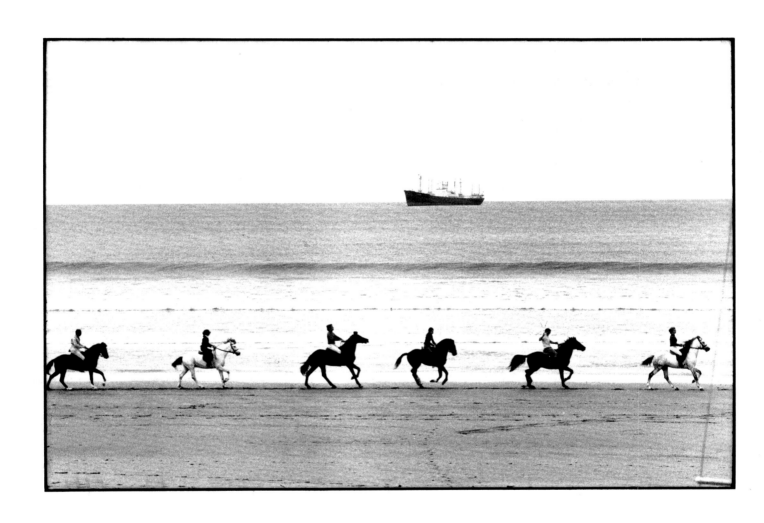

| **Morocco, 1973**

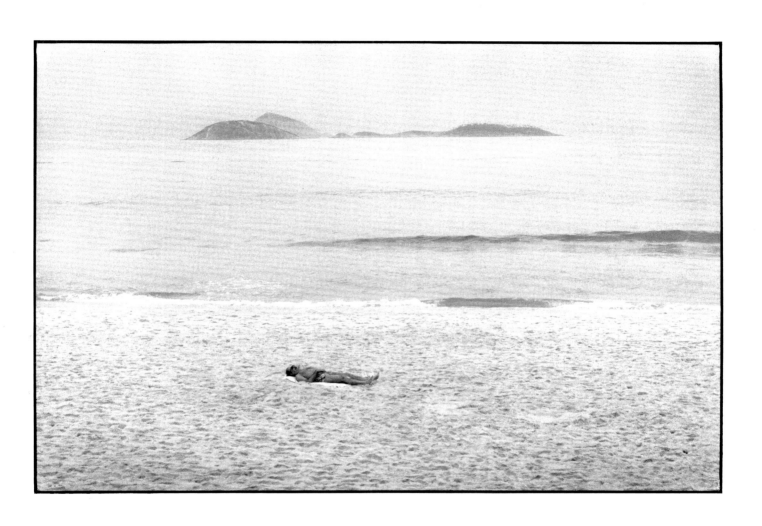

115 | **Rio de Janeiro, 1986**

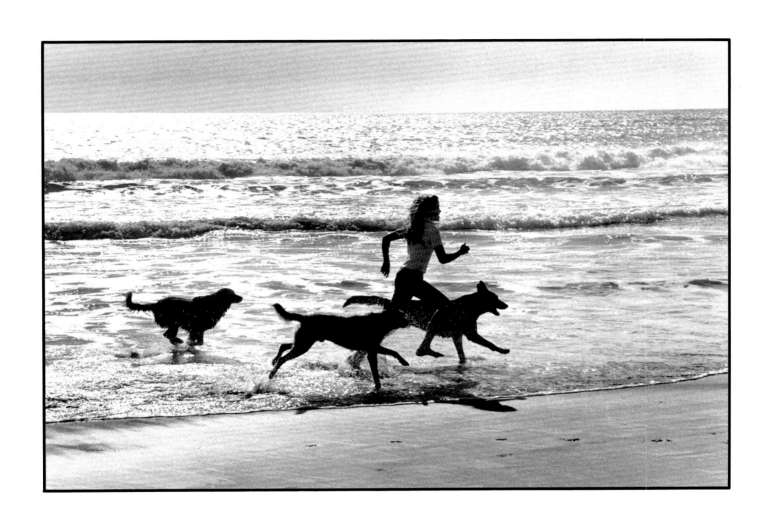

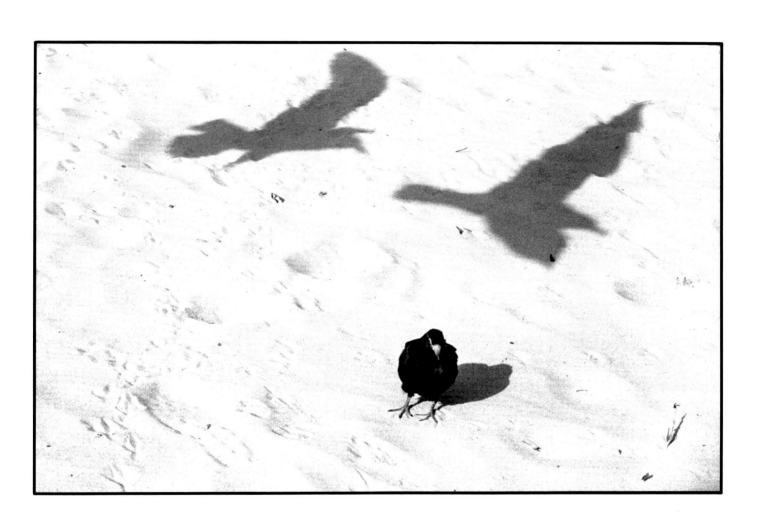

117 | **Miami Beach, Florida, 1984**

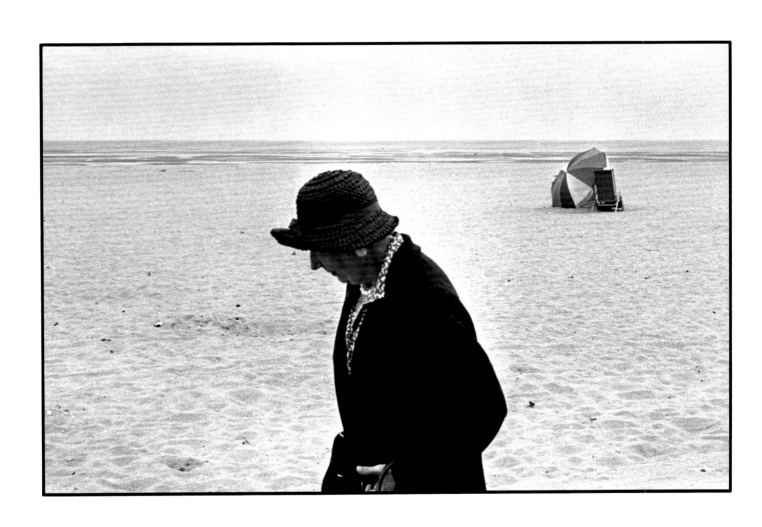

118 | **Trouville, France, 1965**

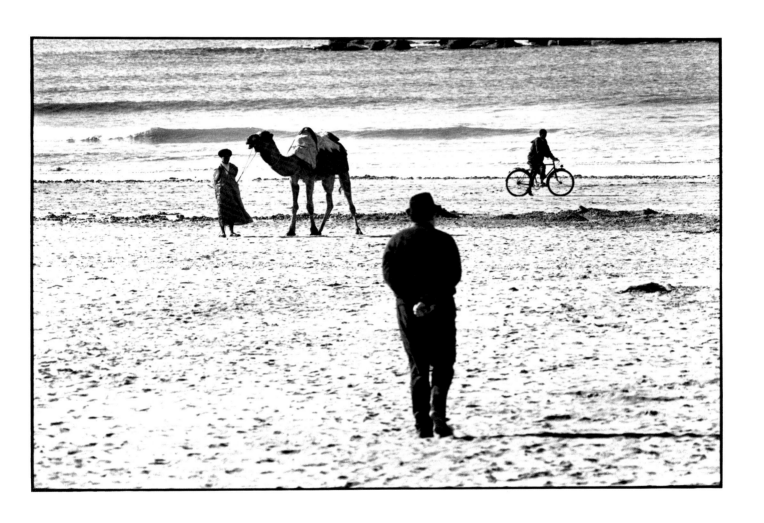

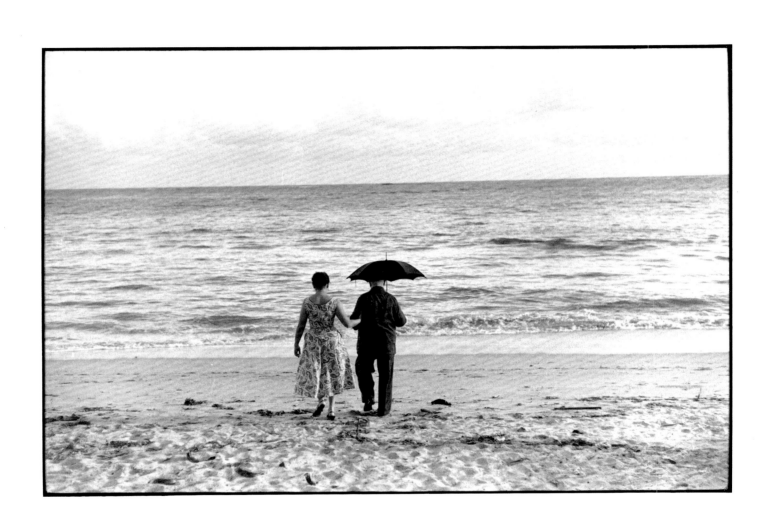

120 | **San Juan, Puerto Rico, 1957**

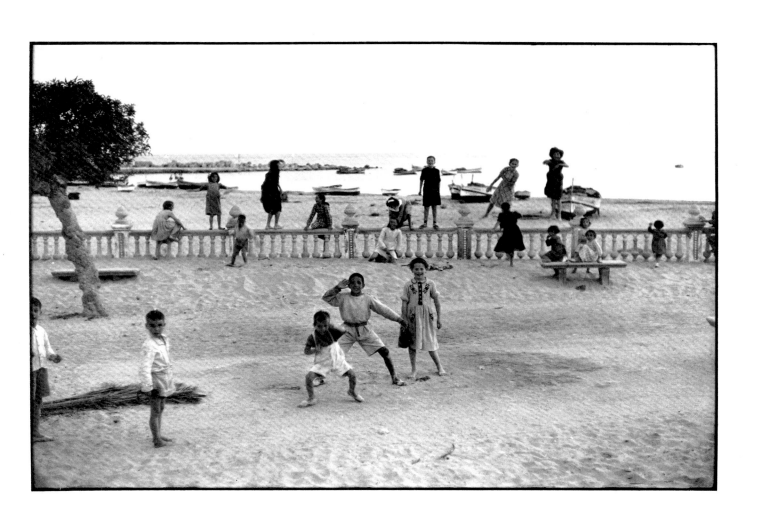

| Valencia, Spain, 1952

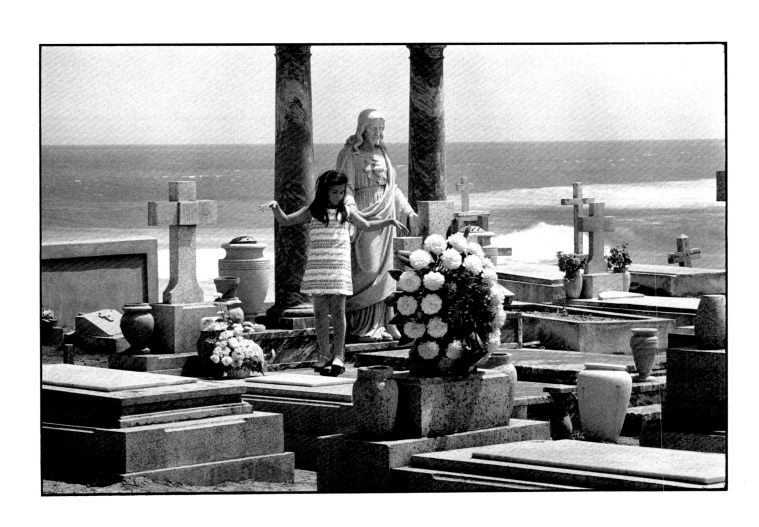

122 | **San Juan, Puerto Rico, 1969**

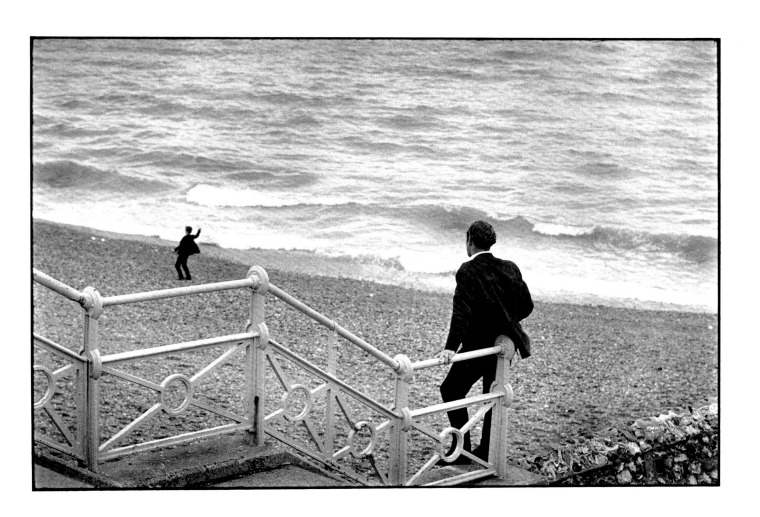

123 | **Brighton, England, 1966**

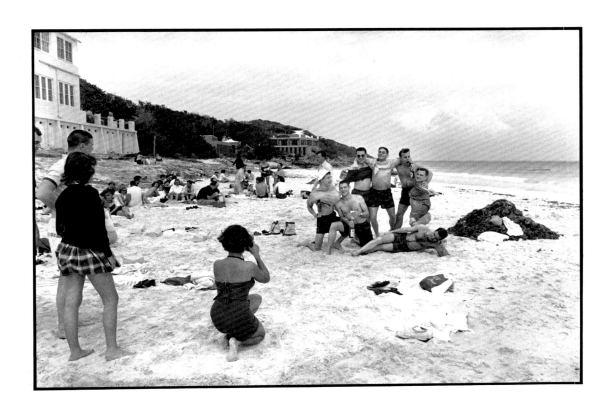

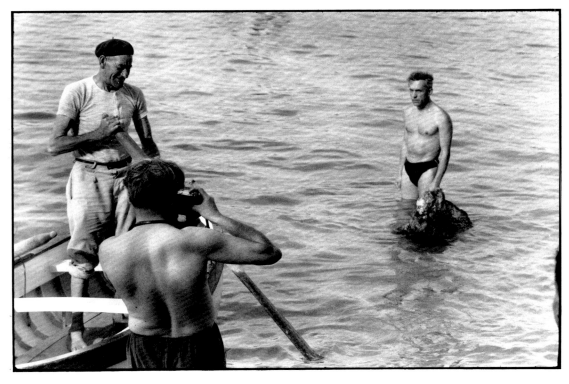

124 | Hamilton, Bermuda, 1953; Capri, Italy, 1954

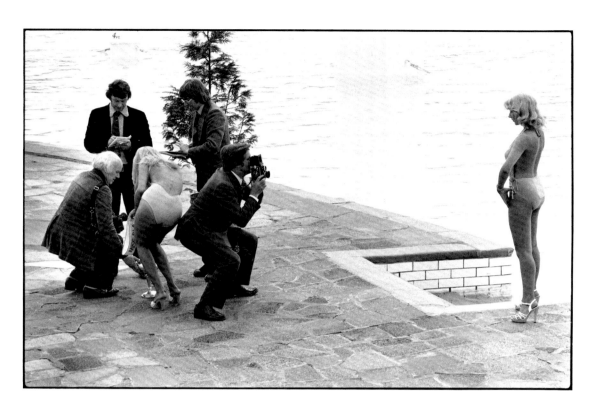

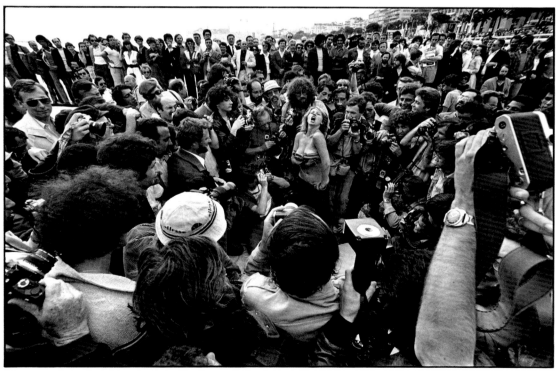

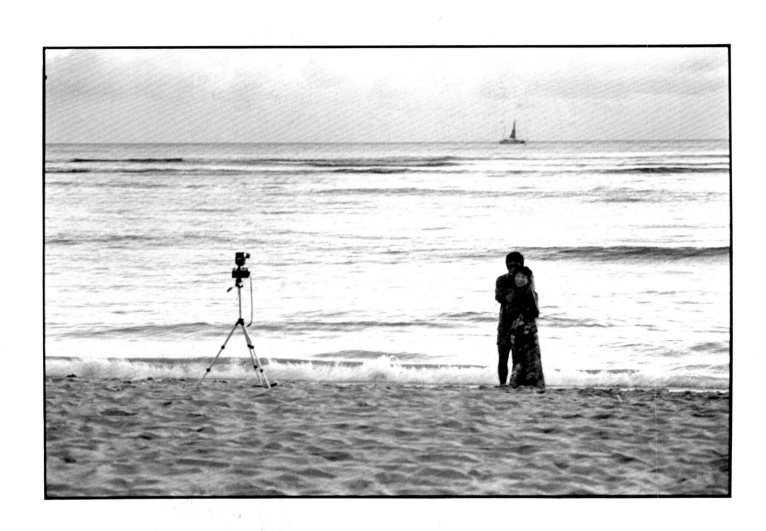